To Christy;
A special friend with
whom I share many
good memories

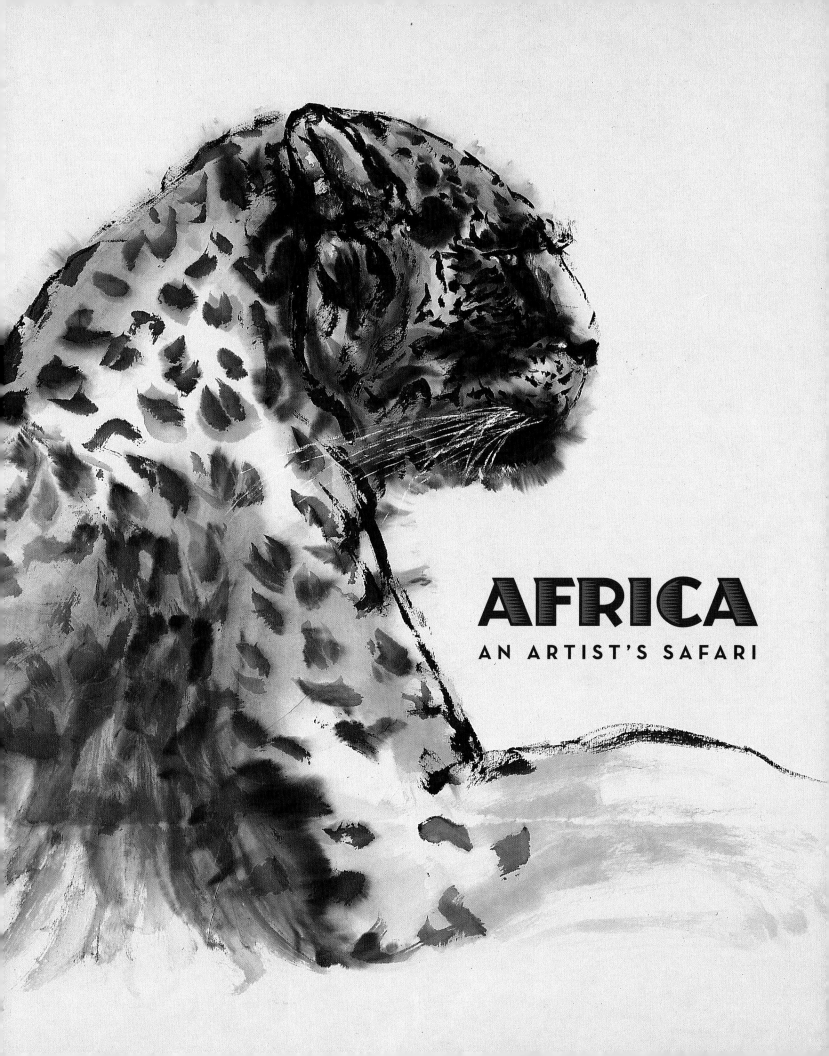

AFRICA

AN ARTIST'S SAFARI

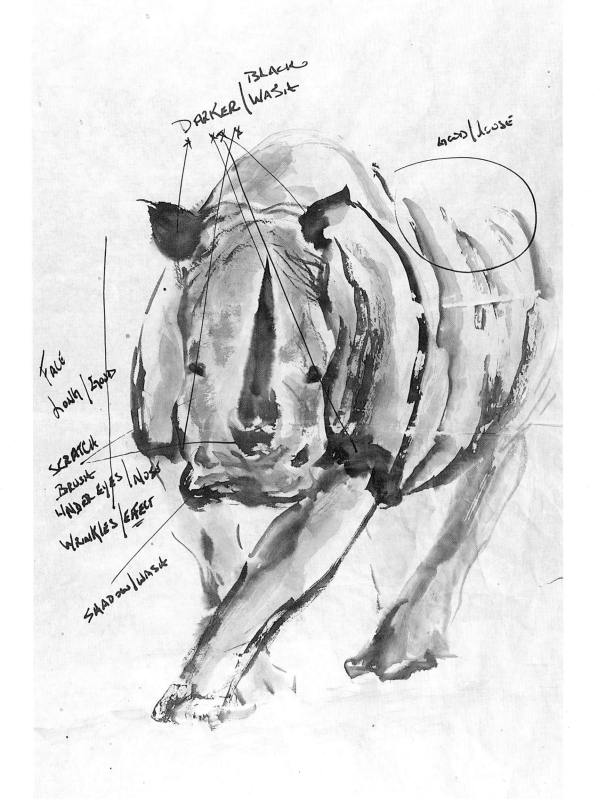

AFRICA
AN ARTIST'S SAFARI

FRED KRAKOWIAK
with Barbara Balletto

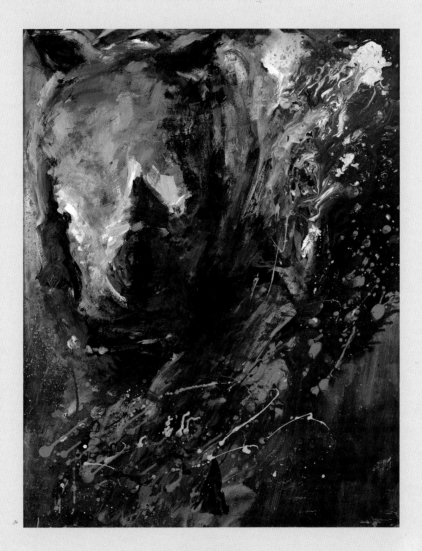

MAVERICK BRUSH STROKES
Scottsdale, Arizona

Published by Maverick Brush Strokes, LLC
11914 East La Posada Circle
Scottsdale, AZ 85255
tel: (602) 376-5431
www.maverickbrushstrokes.com

 Produced by BookStudio, LLC

BookStudio

Contributing writer Barbara Balletto
Edited by Karla Olson, BookStudio, LLC
Copyedited by Lisa Wolff
Photography by Bob Springgate
Designed by Sandy Bell
Index by Margaret Hentz
Printed by Golden Cup Printing, Ltd.

ISBN-13: 978-0-9787084-0-5
ISBN-10: 0-9787084-0-7

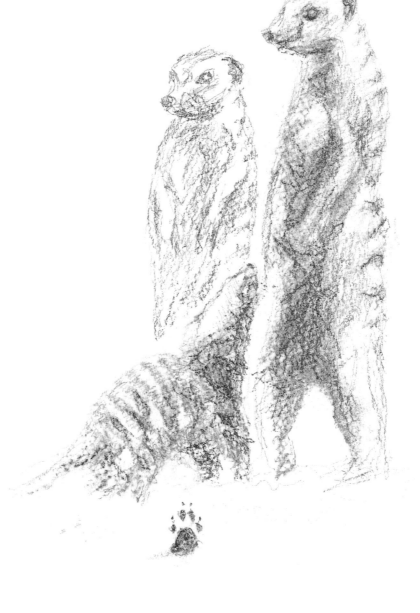

PUBLISHER'S CATALOGING-IN-PUBLICATION DATA

Krakowiak, Fred.

 Africa : an artist's safari / Fred Krakowiak with Barbara Balletto. —
1st ed. — Scottsdale, Ariz. : Maverick Brush Strokes, © 2007.

 p. ; cm.

 ISBN-13: 978-0-9787084-0-5 (hardcover)
 ISBN-10: 0-9787084-0-7 (hardcover)
 A memoir of the author's travels in Africa, including paintings,
sketches, and descriptions of studies performed in the field.

 1. Krakowiak, Fred—Travel. 2. Safaris—Africa—Pictorial works.
3. Africa—Description and travel. 4. Natural history—Pictorial works.
5. Artists' books. 6. Artists' writings. 7. Artists' tools. I. Balletto, Barbara.
II. Title.

N7433.35.A35 K73 2007 2006929103
700—dc22 0704

PAGE 1: Leopard, ink and watercolor on rice paper, 2005
PAGE 2: White rhino, ink and watercolor on rice paper, 2005
PAGE 3: White rhino, oil on copper, 30 x 39 in., 2005
THIS PAGE: Mongoose, charcoal on cold press paper, 2005

CONTENTS

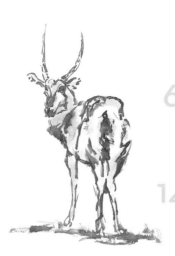

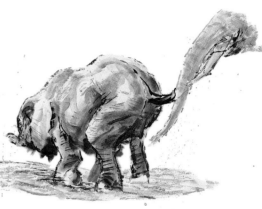

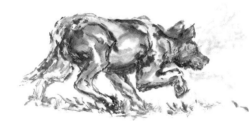

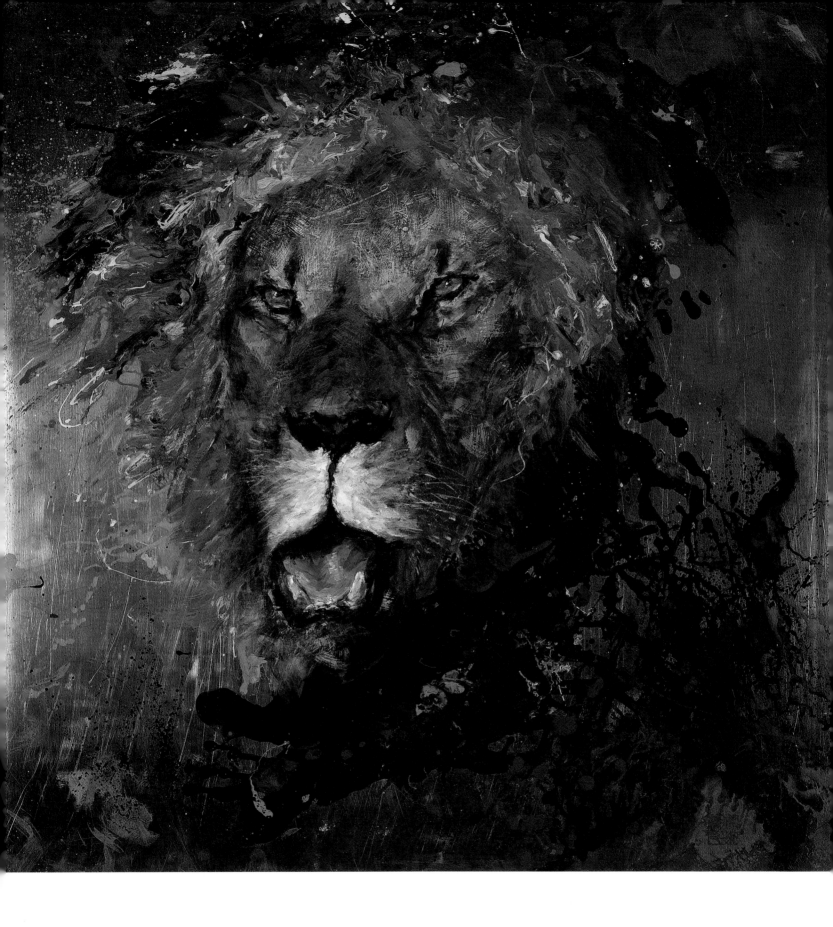

Lion, oil on copper, 38 x 38 in., 2006

Why I Painted My Way to Africa

ALION IS A MAJESTIC ANIMAL.
If you are fortunate enough to see this spectacular beast in his natural habitat, close enough to witness the tone of his eyes and the sparkle in the middle of his pupils, you will feel small and powerless. You will see the reddish tinge to his mane, his wide cheekbones, his soft muzzle. He will gaze silently at you, and you will feel frozen in time. He will roar, and you will be shaken to the very roots of your soul. It will be abundantly clear that this is *his* territory, *you* are the guest, and he is letting you share it with him for only a brief—though unforgettable—moment.

When you are kneeling on the ground and an elephant comes crashing through the bush within seven feet of you, trunk down and ears flapping menacingly, you know this animal was put on earth for a reason and commands respect. The elephant aids in irrigating and fertilizing the land by uprooting trees with its agile trunk. The same enormous foot that can crush your chest in a split second can also dig into the sand and swampland, leaving valuable water holes for small fish and waterfowl. The elephant's determined stride breaks paths for other creatures as it makes its way through thick foliage.

The lion and the elephant are just two of many amazing creatures that call Africa home. There is no other place on earth that evenly remotely compares to this wondrous land. It is truly the adventurer's last frontier—a vast and diverse

Lion track, ink wash on rice paper, 2005

The hunter who wanders through these lands sees sights which ever afterward remain fixed in his mind. . . . Apart from this, yet mingled with it, is the strong attraction of the silent places, of the large tropic moons, and the splendor of the new stars; where the wanderer sees the awful glory of sunrise and sunset in the wide waste spaces of the earth, unworn of man, and changed only by the slow change of the ages through time everlasting.

—PRESIDENT THEODORE ROOSEVELT

wilderness stretching from the Cape of Good Hope in the south to the Mediterranean in the north. Here you'll find the world's largest desert as well as its most extensive rain forest, the world's second-largest freshwater lake and its longest river. Some 840 million people inhabit the second-largest continent, speaking more than 1,000 different languages.

But of paramount interest to me as I was winging my way from New York to Johannesburg, South Africa, (with companions that included my enthusiastic 80-year-old aunt, Jane) was the continent's fascinating wildlife. Africa's game reserves are the largest on the planet, harboring nearly 1,600 species of mammals and about 2,300 species of birds—including four of the world's five fastest land animals (the cheetah, wildebeest, lion, and Thomson's gazelle), the tallest mammal (the giraffe), and the largest land mammal (the elephant).

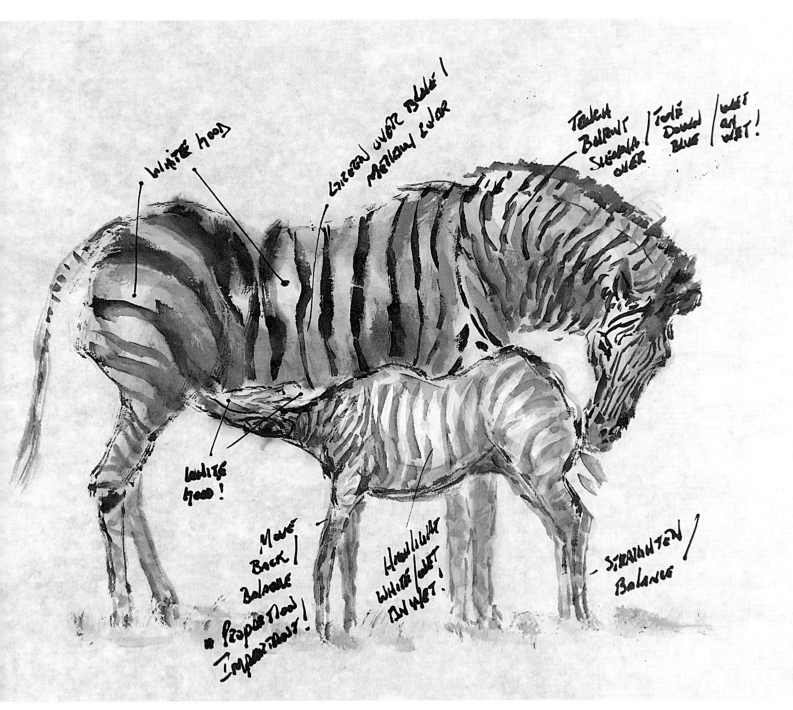

Zebra mother and foal, ink and watercolor on rice paper, 2005

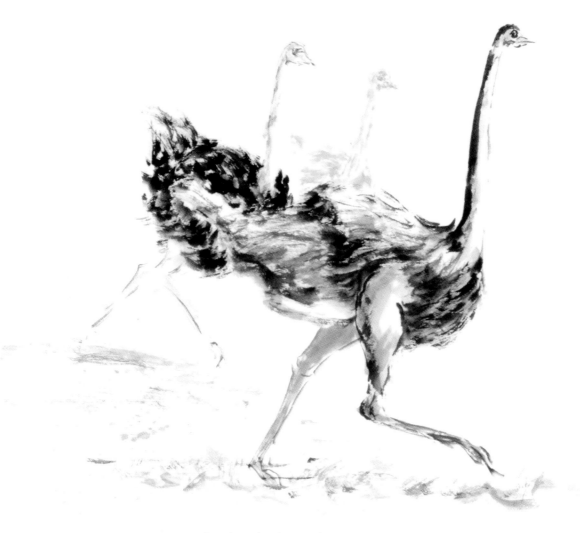

Ostriches, ink and watercolor on rice paper, 2006

This was the Africa I had dreamed of, the one I had read about in countless books and of which I'd heard exciting tales from those who knew the continent well: men I had befriended at the safari convention I attend annually. In recent years, however, the tone of my friends' conversation had started to change. There was more and more talk about the depletion of the game due to several factors, including the increasing human population, poaching, and even government mismanagement of wildlife issues. For instance, fences, walls, and ditches created by humans increasingly interrupt the powerful elephant's path. These magnificent beasts and most other wildlife are forced into smaller and smaller territories; their populations become dense, they compete for the land and resources, and their numbers dwindle.

Poaching has become rampant on the continent and is changing the whole structure of wildlife in Africa in indirect as well as direct ways. Several countries have

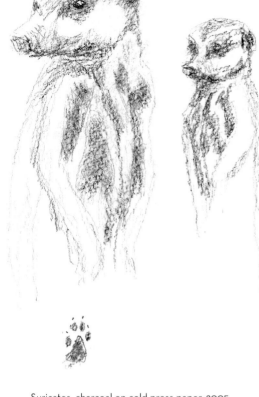

determined that the only way to save their rhino population is to cut off the item the poachers covet: the horn. Wildlife officials did just that to a rhino in Botswana, near the Zimbabwe border. When Zimbabwe's solitary white rhino crossed into Botswana, officials cut off its horn, too, for its protection. The inevitable finally happened: the two hornless male rhinos met and fought a bitter battle over territory. Deprived of their only real weapon, the rhinos' sole defense was to ram each other, and this they did vigorously for some four hours, until one of them eventually hemorrhaged. Yes, the rhinos were no longer desirable to poachers, but without their horns, their natural pattern of behavior became destructive.

Suricates, charcoal on cold press paper, 2005

The odds against the animals are overwhelming. I firmly believe what will eventually happen—unless there is a major overhaul in government regulations—is that a lot of animals in certain parts of the African continent will become extinct. Oh, you'll be able to see them, but only at some huge "African farm," like the wildlife parks we have in America. The financial backing required to save the wildlife is enormous, and a workable solution doesn't seem to be in sight.

A LIFE-CHANGING EXPERIENCE

Listening to the long, concerned discussions and lively debates at the safari conventions—among friends who love the country and know what is happening—it became clear to me that there were simply too many factors screaming that the sand in the hourglass was running out. I realized I had to see these majestic animals myself—in their natural habitat—before they all disappeared.

In the great scheme of things I spent very little time in Africa, yet so many of my dreams came true. I floated down one of Africa's major rivers, under constant threat

from rushing hippos and menacing crocodiles. I came face to face—literally—with earth's largest land mammal, the elephant. I witnessed the strong bond of love between a mother leopard and her cub. These and other experiences are indelibly etched in my memory for eternity.

I never dreamed, however, that my trip to Africa would be a journey of personal discovery: of who I really am, of where I belong in the universe, of awareness of the astounding privilege of sharing this world with an amazing array of wild and wonderful creatures that belong here every bit as much as I do, possibly more. To see an animal in its natural environment, where you're the guest, is a priceless experience. This is not a zoo, not a wildlife park. It's unscripted, unplanned, and unpredictable. Sadly, it's also becoming increasingly threatened.

There are only 30 white rhinos left in Botswana. There are none in Zimbabwe. I was fortunate to see one with a calf just one hour before I was scheduled to return to America. It was an awesome and sobering encounter. The beautiful cheetah, too, is becoming rare, certainly in southern Africa. In 15 days, I saw only one. There are only 600 gorillas left in the wild; someday I would love to see at least one of them in its natural habitat, before they, too, are gone.

Traveling to Africa was a life-changing experience for me. It affected my outlook on life personally, and it affected my art. It is as if a light has gone on inside me. I'm now much more relaxed than I was before the trip; I'm much more open-minded. My art has definitely improved. I look at some of the paintings of animals I had done before I went to Africa and compare it to what I've done since, and there's a distinct difference. My paintings are now more vital; they have more life.

I am blessed with the gift of being able to look at this wildlife with an artist's eye, to soak in every detail, every nuance of an animal's very existence. For this I am grateful, because I am able to preserve what I see by painting it on silk, on rice paper, on copper, in bronze. I am painfully aware that one day my artwork may be all that remains of these majestic creatures.

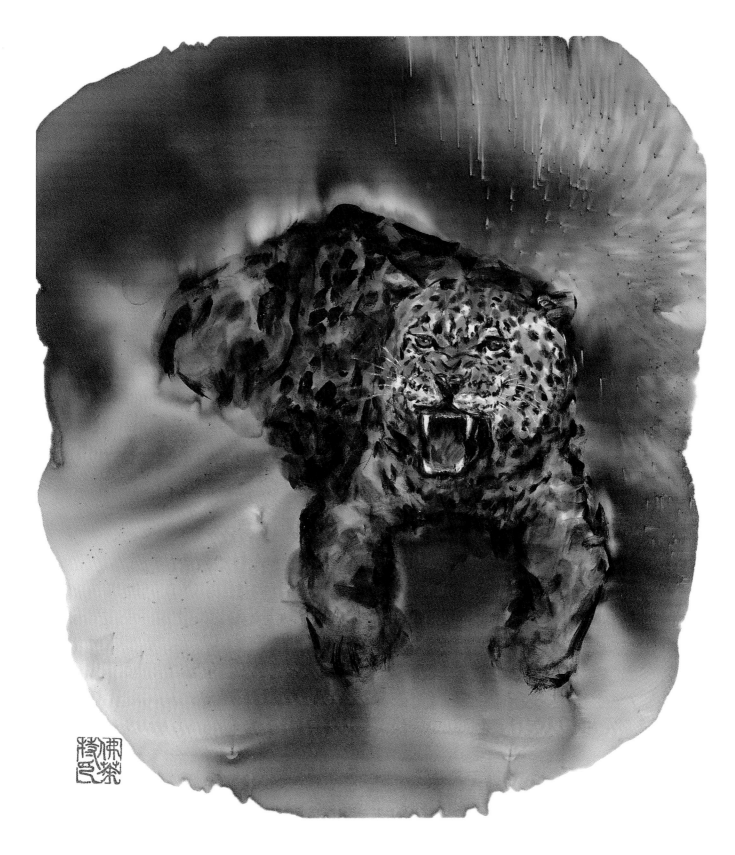

Leopard, dye on silk, 28 x 20 in., 2005

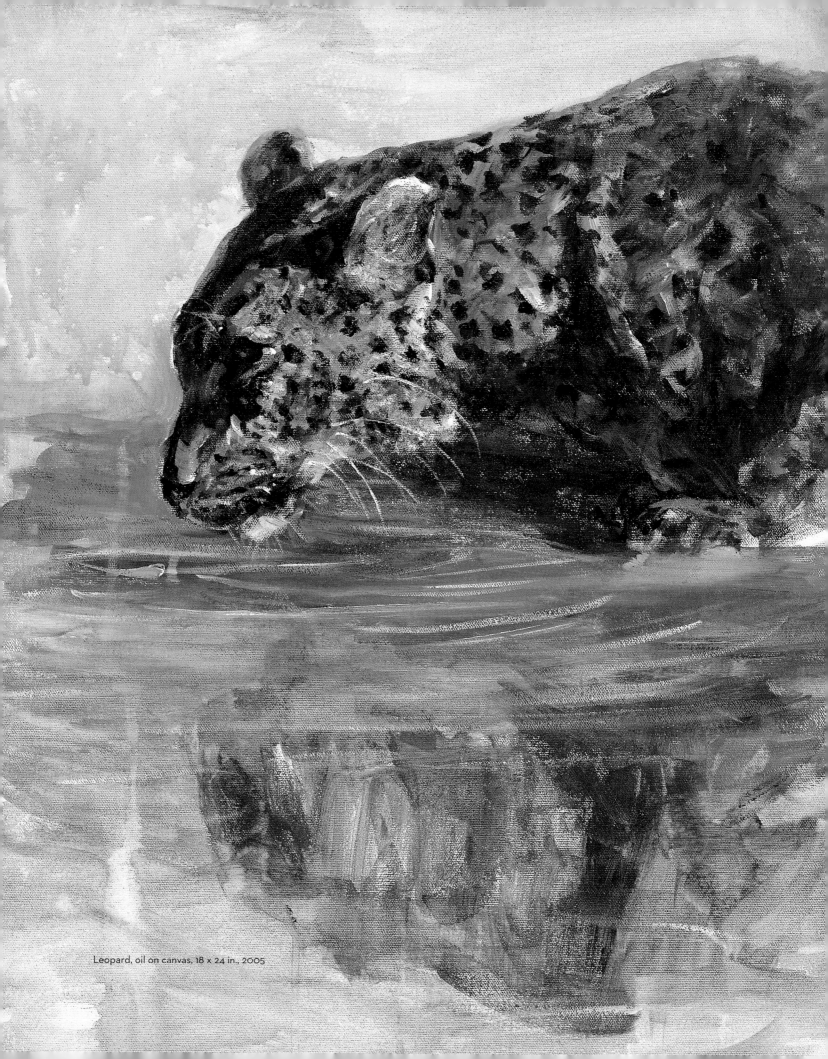

Leopard, oil on canvas, 18 x 24 in., 2005

On the River

THE TIME SPAN FROM THE DAY I made up my mind to go to Africa to the day I got on the plane was approximately 18 months—a year and a half of planning, anticipating, imagining, hoping, and wondering. There were special items to purchase, details to be ironed out with our safari outfitter, and many questions to ask. I was actually packed and ready to go well before our departure date. The wait was excruciating, my excitement infectious to all who knew me. On the day that I actually boarded a plane for Africa, sleep was—not surprisingly—elusive.

We spent only one brief night in Johannesburg, the largest city in South Africa and a major industrial center, before boarding a commercial jet heading for Harare, Zimbabwe. Here we transferred to a light charter aircraft to Mana Pools National Park, where our African adventure began.

Zimbabwe, known as Rhodesia in its days as a British colony, sits on the Tropic of Capricorn in southern Africa. It is more than 152,000 square miles in area, or about the size of California. The country is blessed with great mineral wealth, including gold and silver; fertile soil; wonderful scenery; and abundant wildlife. Since its independence from Britain in 1965, Zimbabwe has gained a reputation as one of the finest game-viewing countries in Africa, with 291 land mammals represented, including those sought after by many visitors, the Big Five: lion, leopard, rhinoceros, elephant, and Cape buffalo.

Waterbuck, ink and watercolor on rice paper, 2005

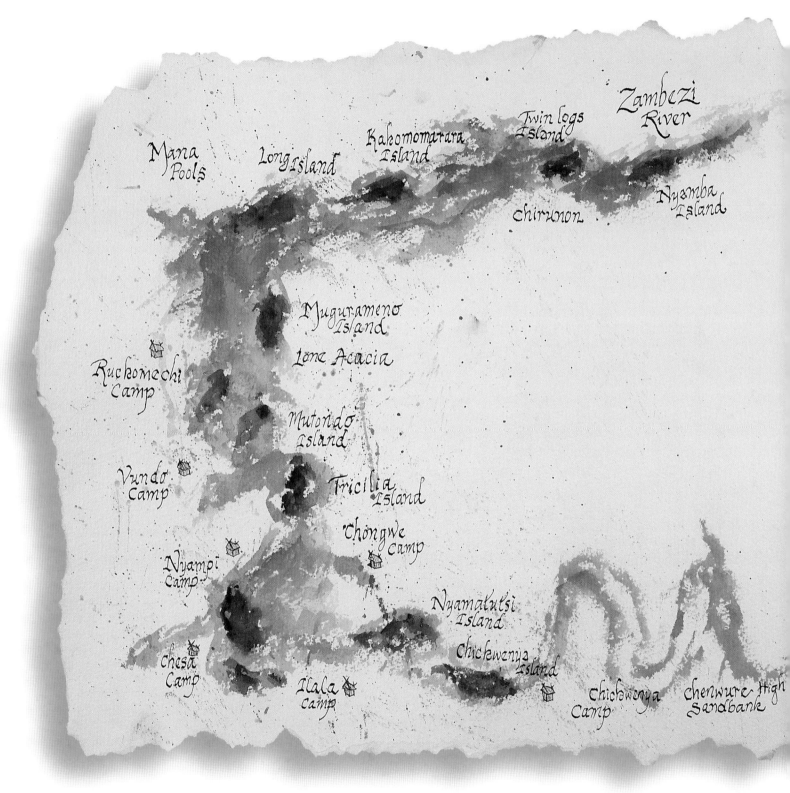

Mana Pools area of the Zambezi River, ink and watercolor on cold press paper, 2005

Elephants at watering hole, ink and watercolor on rice paper, 2006

Two major rivers form Zimbabwe's northern and southern borders: the languid Limpopo marks the country's southern boundary with South Africa, and the mighty Zambezi—Africa's fourth-largest river—creates its northern border with Zambia. We headed to the shores of the Zambezi, where Mana Pools National Park, one of Zimbabwe's four World Heritage Sites, is the stage for a classic theater of the wild. The number of visitors is strictly controlled here to protect the delicate environment; the park itself is open only between April and October.

Our base for this first night in the African bush was Chikwenya Camp, on the eastern boundary of the park. We climbed into an open Land Rover at the tiny dirt airstrip and endured a rough hour's ride to the camp. On the way, we passed three or four magnificently grotesque baobab trees. They were huge, hollowed out, and spectacular; one even had a hammer-and-sickle emblem carved into it, no doubt a remnant of Soviet presence in the country in years gone by.

The camp exceeded our expectations. Situated on the bank of the Zambezi River, it featured three or four permanent tents on platforms, as well as a main building. As is common in most of the camps and lodges on any African safari, there was no electricity; limited power came from a generator. My bed overlooked a marsh of the river. With the tent flaps rolled back, I could lie back and enjoy my own private view of the African bush.

Mupata Gorge

Baobab tree, ink and watercolor on rice paper, 2005

THE MARVELOUS BAOBAB

One day when we were out for a walk, our guide stopped by a huge baobab tree, peeled off some bark, and started rolling it up and down his leg. As we looked on curiously, he mysteriously said, "I'm doing something for the girls." Before our eyes, and in a matter of minutes, he took three pieces of bark, rolled them up and down his leg until they became like twine, and fashioned them into a bracelet. He told us the people of the region also made whips and ropes in much the same manner.

I was intrigued and wanted to try this procedure myself. I rolled the bark up and down my leg to no avail—and to the extreme amusement of my guide, who cried, "You can't do that—you have hair on your legs!" Our guide, like most of the people of sub-Saharan African, had virtually no body hair, allowing him to easily break down the individual fibers in the bark and twist them into a twine or rope.

The baobab (*Adansonian digitata*), found on the savannas of Africa, is a fascinating tree. It can grow to a height of more than 80 feet with a girth of more than 60 feet and can live for several thousand years; for nine months of each year it is leafless and looks every bit like a tree that has been uprooted, turned upside down,

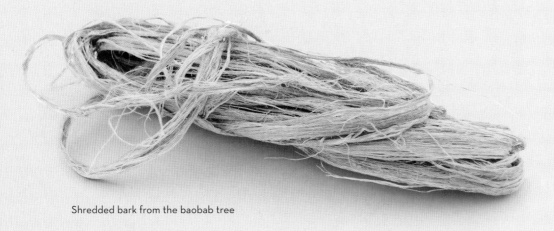

Shredded bark from the baobab tree

and shoved in the ground again, with only its roots showing. An African legend explains that the baobab was among the first trees to appear on the land, followed by the tall, graceful palm tree. When the baobab saw the palm tree, it cried out that it wanted to be taller. Then the beautiful flame tree appeared with its bright red flowers, and the baobab was envious of its blossoms. When the baobab saw the magnificent fig tree, it prayed for fruit as well. As the legend goes, the gods became angry with the tree and pulled it up by its roots, then replanted it upside down to keep it quiet.

Africans use all parts of the baobab: bark, leaves, fruit, and trunk. People often hollow out the massive trunk to use as shelter, grain storage, a water reservoir, or even a burial site. Some of the most important products come from the bark of the tree, which contains a fiber that is used to make fish nets, rope (as described above), sacks, and clothing. The bark is also ground into a powder for flavoring food. The leaves of the baobab were tradi-

tionally used for leaven but are also used as a vegetable. Its fruits and seeds are also edible for both humans and animals. The pulp of the fruit, when dried and mixed with water, makes a beverage that tastes similar to lemonade. The seeds, which taste like cream of tartar and are a valuable source of vitamin C, were traditionally pounded into meal when other food was scarce. Other products, such as soap, necklaces, glue, rubber, medicine, and cloth, can be produced from the various parts of the baobab tree.

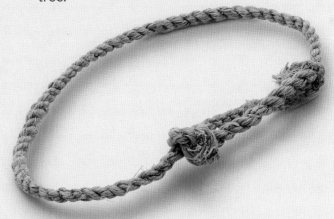

Bracelet made from the bark of the baobab tree

THE AFRICAN NIGHT

On this, my first evening on this intriguing continent, the African night beckoned more than my bed. Our guide suggested a night game drive, and we jumped at the chance. Within minutes we piled back into the Land Rover again, armed with powerful lights to illuminate the fascinating world that comes alive when the sun goes down. Here we were, new to Africa, and no more than 100 yards outside of camp we saw our first elephant, a young solitary male, who stood there flapping his ears as if in welcome. How could it get any better than this? We were so excited that all thoughts of dinner and rest back at the camp disappeared.

THE WORLD'S LARGEST LAND MAMMAL

The African elephant (*Loxodonta africana*) is the world's largest land mammal, and to see one beside your vehicle is truly overwhelming. Males can weigh up to 13,200 pounds (yes, that's more than six and a half *tons*) and may stand up to 11 feet tall; the smaller females reach a maximum of 7,700 pounds and stand just over eight feet tall. Their tusks average 134 pounds for males, 42 pounds for females, but the largest tusks on record were an amazing 293 pounds and about 11 feet long. One can only imagine and marvel at the size of the elephant that carried those around.

Today's African elephant is smaller than the elephant of 50 years ago and has smaller tusks. Why? Experts theorize that over the years hunters, always trying to bag the largest "tusker," have extinguished the gene pool. By killing only tusked elephants, African ivory hunters have given elephants with small tusks or no tusks at all a much greater chance of mating. The propagation of the absent-tusk gene, once very rare, has resulted in the birth of large numbers of tuskless elephants, now approaching 30 percent in some populations. Could the continued selection pressure bring about a complete absence of tusks in African elephants, a development normally requiring thousands of years of evolution? The effect of tuskless elephants on the environment, and on the elephants themselves, could be dramatic. Many

Elephant foot, ink and watercolor on rice paper, 2005

African Elephant
(Loxodonta africana)

MARKINGS: Light to dark grey, sometimes blackish; skin finely wrinkled, sometimes visibly haired. Smooth forehead, tip of trunk with two grasping "fingers," very large ears. Males and females have tusks (although many females in Mana Pools area are tuskless and may be evolving this way). Tusks are large and curved forward; largest on record weighed 293 pounds and were 11 feet long. Tusks average 134 pounds for males; 42 pounds for females.

SIZE: Males can weigh in at up to 13,200 pounds and up to 11 feet tall; the smaller females reach a maximum of 7,700 pounds and just over eight feet tall.

BEHAVIOR: Very matriarchal society, an adult female in charge of calves of different ages. Young females stay with or near cows; the young males eventually leave the mother troop and form separate troops or become companions with an old male. Old males may become solitary. Family troops usually number ten to 20 members; in seasonal wanderings there may be a loose association of several troops, with several herds forming larger herds, sometimes numbering in the hundreds. Because daily food requirements average 200 to 400 pounds of food, elephants spend much time browsing and feeding, as well as drinking and bathing at water holes. In birth, injury, or sickness, elephants help each other; at the death of a companion, an elephant will remain on watch by the body (a cow may drag off the body of her small calf for a whole day), often covering a corpse with branches.

GESTATION: 22 months, one active young; twins very rare. Suckling period usually two years.

LIFE SPAN: Up to 60 years.

PREDATORS: Lions, spotted hyenas, hunting dogs, and crocodiles may attack weak, young calves if left unsupervised; otherwise cows and herd protect calves successfully.

DEFENSE: An elephant will often stage a "mock charge," a terrifying display of ground stomping, ear flapping, and frantic screaming, designed to scare off would-be predators. Should a predator escape this mock charge, the elephant's best defense is its sheer size and strength; its agile trunk and strong tusks can do a lot of damage when force is needed.

CONSERVATION: Despite the post-ivory-ban recovery of some elephant populations, the total number of elephants across Africa—thought to be between 300,000 and 600,000—is actually half what it was estimated to have been 40 years ago. The biggest problem lies in ensuring there is enough land to conserve viable populations of this gentle giant.

female elephants at Mana Pools, home to more than 12,000 of these magnificent creatures, do not have tusks and are much more aggressive than those with tusks.

An elephant can live for up to 60 years; the lone male we encountered was probably at least 12. Depending on the onset of adolescent behavior and its subsequent intolerance by cows with young calves, males leave cow herds at age 12 or shortly thereafter. Now on his own, this "teenager" will alternately wander solo and hang out with other bulls, typically in herds of two to 14 but occasionally in herds of more than 35 and sometimes as many as 144, all of different ages.

You know . . . they say an elephant never forgets. What they don't tell you is, you never forget an elephant.

—BILL MURRAY, ACTOR

Elephant track, ink wash on rice paper, 2005

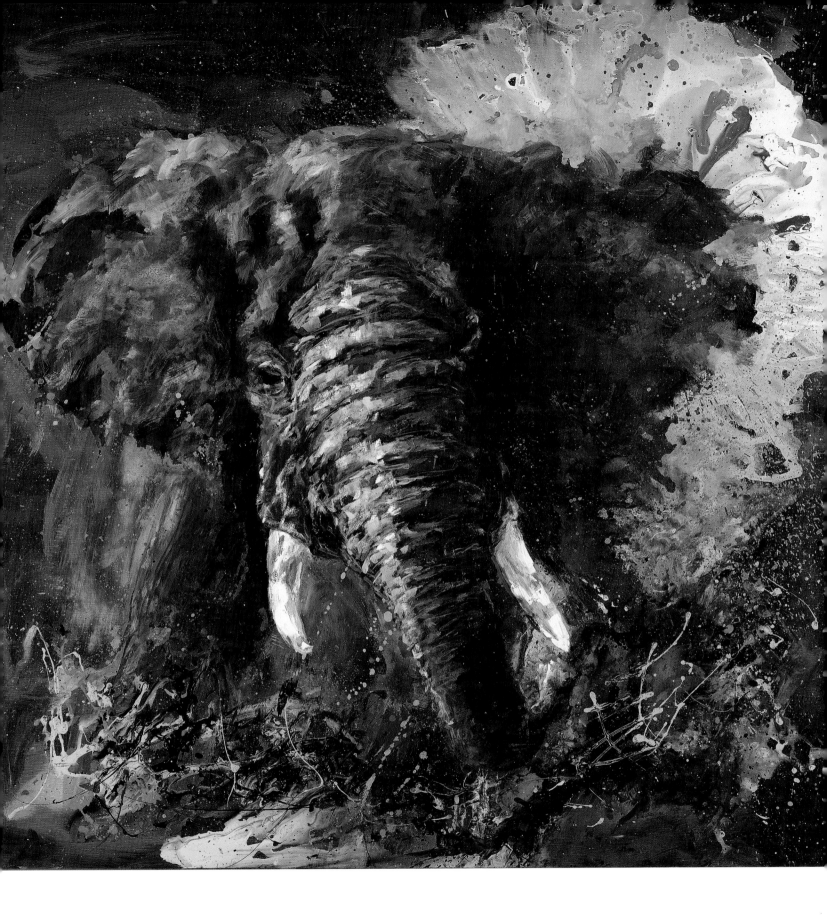

Elephant, oil on copper, 36 x 36 in., 2006

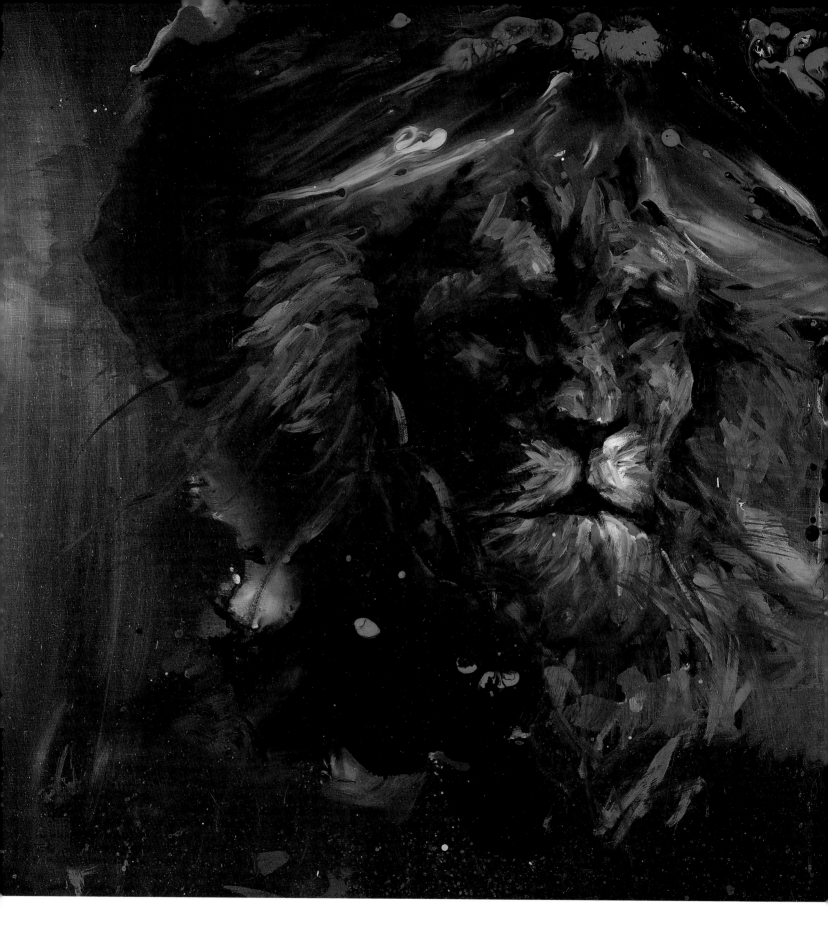

Lion, oil on copper, 32 x 32 in., 2005

AFRICA'S LARGEST CAT

The next eyes caught in our powerful light were those of three young male lions. The lion (*Panthera leo*) is Africa's largest cat, with an adult male weighing as much as 550 pounds and standing up to five feet at the shoulder. This "king of beasts" lives in prides that range from five to 40 members, all lorded over by one or two mature males. Much of their life—about 20 hours a day—is spent sleeping, but they've always got one eye half open for an opportunistic kill. Most lions make their kills at night, and 80 to 90 percent of the time the dirty work is done by the lionesses.

However, it was quite possible these three lads were looking for a meal. Known as nomadic lions, they were probably brothers who began their wandering at about the age of three and a half, after being expelled from their pride by the dominant males. One day, having grown enough in strength and prowess, they will challenge a pride male, usually through a violent-looking but bloodless battle that consists of fierce snarls and flailing claws. Sometimes, however, the challenge escalates into a fight to the death.

LION *(Panthera leo)*

MARKINGS: Color varies from tawny grayish yellow to dark reddish brown. Mane in males begins to grow about one-and-a-half years and is fully developed at five to six years, regionally varying from a short facial surround with a neck mane to a longer, broader mane covering much of the upper body. Mane color varies regionally from light yellow to black.

SIZE: Adult males can weigh up to 550 pounds and stand up to five feet tall at the shoulder; females are smaller, weighing up to 400 pounds.

BEHAVIOR: Lions, like domestic cats, are lazy and spend a lot of time sleeping in shady spots—nearly 20 of 24 hours. They are largely nocturnal, particularly where hunted. An older male reigns over the pride, which ranges in size from five to 40 members. Females generally act as the hunters, usually alone but sometimes in packs to bring down larger prey. Young males are driven out of the pride at one-and-a-half to two years of age, and form smaller bachelor prides until they can take over reign of another pride.

GESTATION: About four months, with a litter size between one and six cubs; usually two to three.

LIFE SPAN: 13 to 15 years in the wild; 20 to 30 in captivity.

PREDATORS: Unguarded young are at risk from hyenas, leopards, and pythons; hyena and hunting dog packs sometimes attack adults.

DEFENSE: Strength and numbers: males will often form coalitions to fight males from another pride or other enemies. Sharp teeth and claws attached to very strong limbs can also do a lot of damage.

CONSERVATION: Less than 20,000 survive in a handful of countries in Africa. Dwindling populations are mainly a result of habitat loss; lions stray past park boundaries to attack livestock and are shot by humans.

I returned to camp with my head spinning from all the new experiences, the new information my brain was trying to process. Dinner was delicious, but the conversation was of the wonders we had already seen, and the prospect of adventure that lay ahead. As my head hit the pillow that night, I was lulled to sleep by the unfamiliar and as yet unidentifiable sounds of Africa—music to my ears.

Leopard track, ink wash on rice paper, 2005

TRACKING ADVENTURE

We rose with the sun the next day and had our first lesson in tracking from our guide, Obert, a native Zimbabwean from the predominant Shona tribe. Obert was raised in this part of the country and knew the land and its animals extremely well. We would be doing a fair amount of walking during our safari, so knowing how to track and how to behave while on foot in the wilds of Africa was of paramount importance.

Hyena track, ink wash on rice paper, 2005

Perhaps more than anything else on this safari, the thought of tracking African game on foot thrilled me. Like hunters of years gone by, I was intrigued to learn to find animals by recognizing the telltale signs of their presence: matted grass in a clearing or torn bark on a tree, perhaps, as well as their spoor, their urine, and the actual tracks they make in the earth. Every cat, I learned, has three lobes in its back print and four in its front, while a dog will only have two. Lion and leopard prints will not show claw marks, because they have retractable claws; a cheetah's claws are not retractable and will be evident in their print. A porcupine track is fascinating: not only do you notice the little footprints, but the trails of the quills as they drag along behind.

Tracks can also reveal important information about an animal. Our guide could tell from looking at the print we'd encountered of a Cape buffalo that the animal had a bad leg. When tracking an elephant, you can measure its

Guide looking for tracks, charcoal on cold press paper, 2005

Hyena track

Hippo track

Zebra track

footprint and multiply the circumference by two and a half to determine its shoulder height. This was all amazing to me. No fancy computers, no high-tech "game finders"—just pure knowledge of the bush, passed along from father to son for generations.

Cape buffalo track

Our lesson complete and our heads reeling with all this newfound knowledge, we ate lunch and headed for the Land Rover for a game drive west to the Ruckomechi camp, where we began what is undoubtedly one of the most exciting safari experiences anywhere in Africa—a trip down the Mana Canoe Trail.

Giraffe track

Cheetah track

All track images this page, ink wash on rice paper, 2005

Black rhino track

ONTO THE WATER

For the next four days, we canoed downstream from one end of Mana Pools to the other, from west to east—from Ruckomechi to Chikwenya, a distance of just under 38 miles. By day, we paddled and floated through superb countryside with spectacular scenery, against the dramatic backdrop of the mountains of the northern escarpment of Africa's Great Rift Valley. One of Africa's most striking geographical features, this giant tear across the earth's surface, extending from the Middle East to Mozambique, is visible even from space.

As we canoed, a support team consisting of a cook and two camp hands moved ahead of us on the ground. Halfway through the day, we would stop for a wonderful lunch served either on the banks of the river or on floating tables set up in the middle of the water. At the end of the day we would arrive to find our designated camp set up for the night. Yes, this was camping in every sense of the word, but never did we want for anything. The tents were large enough to stand in and featured comfortable camp beds and fluffy pillows; a bucket shower was rudimentary but effective, and a very welcome refreshment at the end of a day on the river. Delicious dinners were served up al fresco in great style (no paper or plastic here), accompanied by refreshing Zimbabwean wine.

Humphrey and his apprentice James were our river guides. Armed with rifles, they were responsible for safely leading us less-experienced paddlers down the river, past pods of hippos, crocodiles, and countless other wild animals that make their home along the banks of the Zambezi. We were no sooner in the canoes, in fact, than we came upon our first hippos.

THE MIGHTY HIPPOPOTAMUS

Usually seen in schools or pods—a term borrowed from the whale world—of females with a dominant male, the hippopotamus (*Hippopotamus amphibious*) is a grazing animal that emerges from the water at night. It consumes up to 100 pounds of vegetation in one night, and in times of drought

Hippo tracks, ink wash on rice paper, 2005

it may travel several miles during the evening to get its fill. This large—up to 7,000 pounds—seemingly cumbersome member of the pig family is surprisingly graceful and agile in the water, where it seems to levitate like a moon walker. Indeed, it gallops across a river bottom with great ease, a skill that no doubt earned the hippopotamus its name, which means "river horse."

Hippos live in groups of 15 or more and spend much of the day snoozing in the water, their heads resting on each others' bodies or nearly submerged with only ears, noses, and eyes—conveniently positioned on top of their heads—visible.

When hippos submerge, their nostrils close and their ears fold into recesses; they ordinarily can stay underwater for six to eight minutes and, under duress, up to 20 minutes. Hippos ooze reddish fluid from their skin, which caused ancient Greeks to

Hippopotamus
(*Hippopotamus amphibious*)

MARKINGS: Virtually hairless, the hippo is pink at birth and later grayish-brown, thick-bodied, round-headed with small eyes and ears, short-legged and short-tailed with very large tusklike canines.

SIZE: Can weigh up to 7,000 pounds. Head and body length can reach 14 feet; hippos stand about five feet tall.

BEHAVIOR: Wallow in water most of the day; graze by night, consuming up to 100 pounds of vegetation, sometimes traveling several miles to find enough food. Usually in pods of 15 or more, mainly females and young watched over by an older male. Often-heard mating call is the male's distinctive and loud "muh-muh-muh."

GESTATION: Generally eight months, with one young weighing up to 120 pounds; twins uncommon. Young may be born either in shallow water or on land.

LIFE SPAN: 40 to 45 years.

PREDATORS: Apart from man, few natural enemies; sometimes while solitary animals are on land they may be sought after by lions and, in water, the young are at risk from crocodiles.

DEFENSE: Mainly thick skin and razor-sharp canines. Hippos will threaten by opening their mouths wide, showing their large canines and bellowing like cattle; if this isn't enough to ward off an adversary, they will fight aggressively, using the head like a sledgehammer and biting furiously. If a hippo comes upon a perceived threat in the water, it will often charge; despite their build, they can reach impressive speeds and do some damage to an unsuspecting canoeist.

INTERESTING FACTS: A hippo can close its nostrils and ears, allowing it to submerge for up to 20 minutes. A pink mucous secretion of the skin glands protects the skin from the effects of the water, and also from drying too much on land.

CONSERVATION: Southern Africa's hippo population numbers about 80,000. Its chief threat is loss of habitat, particularly grazing lands due to human cultivation. The animal is also at risk of being killed by man, particularly if the hippo chooses to graze on farmland or attacks fishermen when in the water.

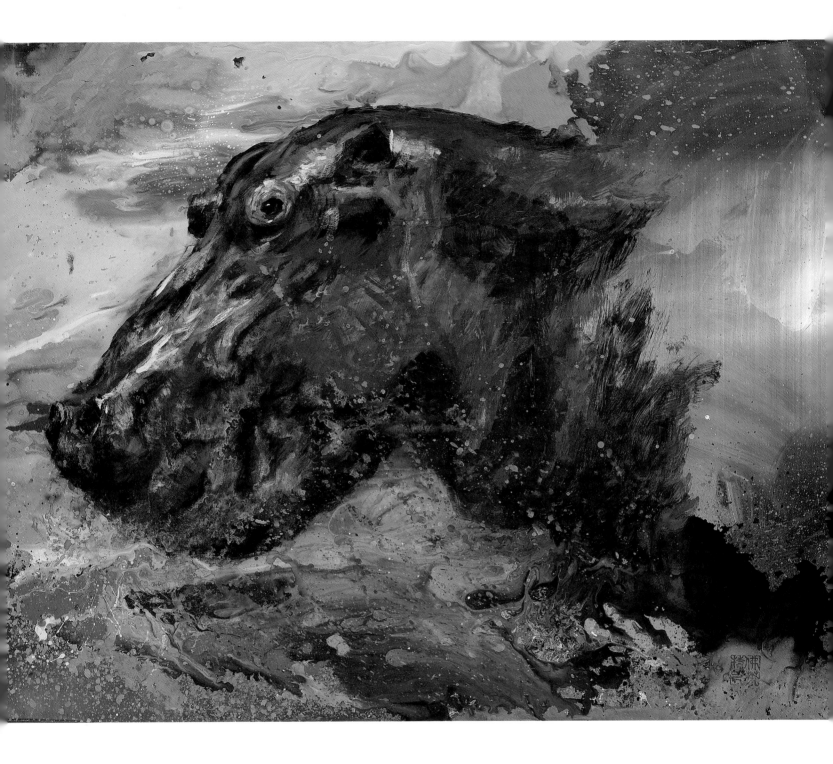

Hippo, oil on copper, 36 x 28 in., 2005

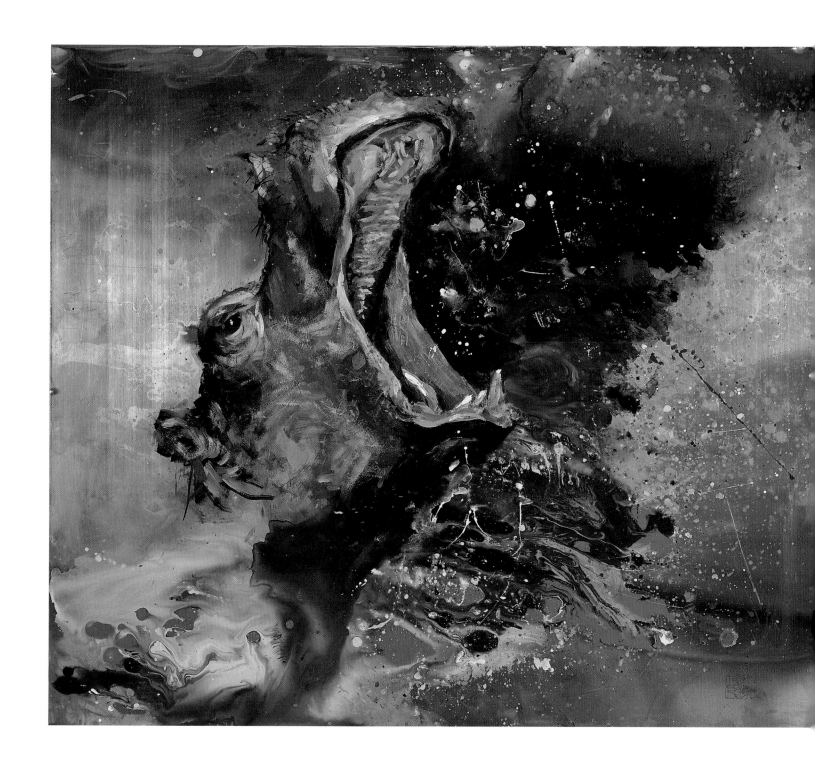

Hippo, oil on copper, 32 x 38 in., 2006

believe they sweat blood. But, in actuality, the hippo's glandular skin fluid contains two pigments: one red, one orange. Current research indicates these pigments may act as a sun screen or perhaps even help heal wounds after a fight. This natural antibiotic goes to work even when the hippo is in the water.

We floated respectfully past the hippo pod for about six miles, which was the extent of our introductory day on the Zambezi. Our camp was ready and waiting for us at river's edge, so we showered and tucked into a hearty meal of lamb, carrots, and potatoes before retiring to our tents. We were lulled to sleep by the not-too-distant "huh-huh-huh" bellows and snorts of the hippos and other mysterious sounds of the African night.

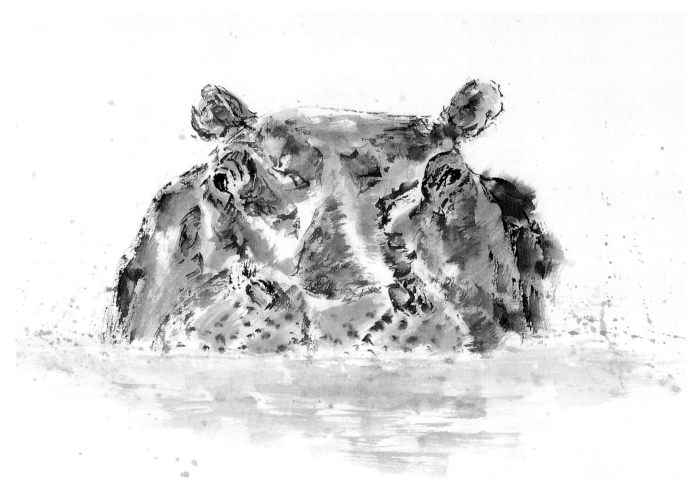

Submerged hippo, ink and watercolor on cold press paper, 2006

There is no creature among all the Beasts of the world which hath so great and ample demonstration of the power and wisdom of almighty God as the Elephant.

—EDWARD TOPSELL, AUTHOR

A CLOSE ENCOUNTER

The next morning, we had breakfast early and were in the canoes as the sun was rising. We spent two hours or so alternately paddling and floating, taking in everything that was around us, before Humphrey, the lead guide, pulled over for a little break and to find some game on foot. We walked for a while without seeing much of anything, then suddenly spotted two or three elephants off in the distance.

One of them, a large bull, was heading our way. Humphrey was armed with a big rifle, but I couldn't help feeling alone and out of my comfort zone. Nevertheless, Humphrey placed me in a spot in a clearing where I could easily get a picture of the oncoming bull. I knelt down, while everyone else stayed 15 to 20 yards behind me. The elephant lumbered along the terrain toward me, and I was impressed with how huge he was. I quickly checked my camera and its settings, took several photos, and allowed myself to relax.

But I had let down my guard too soon. The bull didn't stop; he just kept coming. Finally, he paused, lifted up his trunk to sniff the air—and then, tucking in his trunk, made a rush in my direction. Now he was 25 feet away, under the shade of an acacia tree, fanning his great ears in my direction while his body swayed from side to side. He held his massive head high. Humphrey reassured me that it was only a "mock charge" and to stay where I was. I did as I was told; after all, this was one of the reasons I had come to Africa: for the simple thrill of being exposed to danger while still having the ability to sense what was all around me.

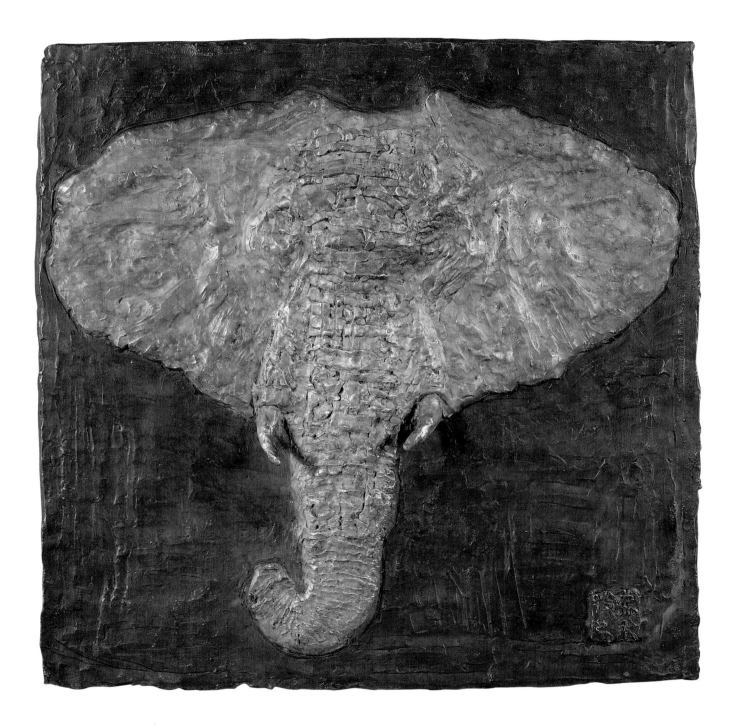

Elephant relief, bronze, 32 x 32 in., 2006

I took a couple of photos at incredibly close range. The elephant's ears continued to fan back and forth; his trunk was down. This was not a happy guy. All of a sudden he rushed again—a massive rush. Now I was scared; my heart was pounding. Humphrey was mouthing, "*Don't* move! You *cannot* move!" The elephant was now so close to me that I couldn't get anything in focus; I couldn't even get his whole head in my viewfinder. I could smell him. I could feel the fanning of his ears. He was kicking up dust; pebbles were bouncing off my forehead and the camera lens. It was unbelievable. Still to this day I feel the fear. With the elephant's huge feet directly in front of me, I was tiny. I could see the whites of his eyes as he looked directly at me; I could see the intricate lines in his trunk and the scars and marks on his giant tusks. The sunlight bounced in a plethora of colors off his trunk and tusks. Then, just as suddenly, there was another huge rush. Dirt was kicked up again. He trumpeted—the screech was ear-piercing—and my attention was fully concentrated on this oncoming, and obviously annoyed, beast. I put the camera down and just watched him. I don't know how much time passed. Two seconds? Twenty seconds? Time stood still. The elephant paused, tilted his head to the right, swayed—and then retreated, giving me one backward glance that I'll never forget. It was as if he said, "This is my territory, and I have decided to allow you to visit. But no more."

After he had gone, we walked off the distance from where I was crouched to where the elephant's right foot had kicked up the dirt. It measured seven steps. This undoubtedly had been the most exhilarating moment of my life.

RESPECTING THE WAYS OF THE WILD

As I discovered later, I had just experienced a textbook mock charge, which is indicated by the elephant's head held high and ears spread wide, and it is usually accompanied by lots of trumpeting and kicking up of dust. Interestingly, elephant researchers have discovered that there is more to a mock charge than meets the eye—or the ear, for that matter. It turns out that foot stomping and low-frequency rumbling generate seismic waves that can travel nearly 20 miles along the surface of the earth, which other elephants may be able to sense through their feet and interpret as warning signals of a distant danger.

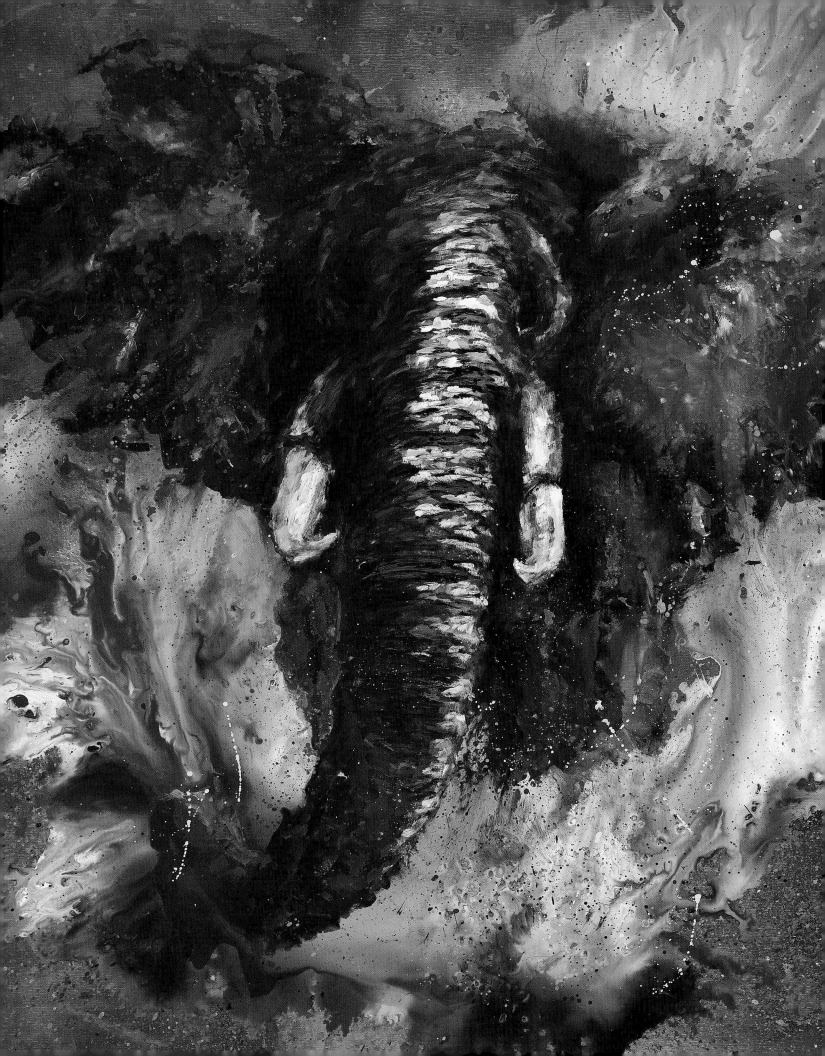

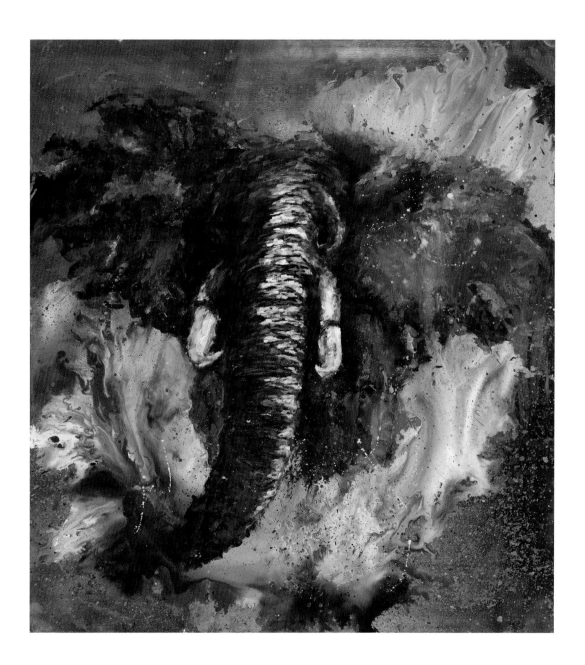

Elephant, oil on copper, 36 x 42 in., 2005

Thompson at Little Mombo, charcoal on cold press paper, 2005

THE GUIDES

The African people in general—particularly those outside the big cities—are incredibly welcoming, warm, and hospitable to foreigners. African safari guides are all this, and more. Every single one of our guides—Obert in Chikwenya, Humphrey and James along the Zambezi, Thuto in Savuti, Thompson at Little Mombo, and Cisco at Vumbura—is quick to laugh; they are all fond of playing pranks on each other, and they're also amazingly knowledgeable about the land and the wildlife that resides there. Most of them, after all, have grown up in the bush, sometimes having been raised only yards from the very camp in which we were staying. They are immensely proud—and protective—of everything in what has always been their "backyard," their playground since they were old enough to walk. They not only know the wildlife, its habits, and habitats, but they are expert trackers and skilled marksmen.

Simply growing up in the bush doesn't make you a qualified guide. In both Botswana and Zimbabwe, candidates go through four years of rigorous training before becoming a fully licensed professional safari guide. Within those four years, the trainee is employed full time by a safari company, under the tutorship of already licensed guides. Trainees are required to study subjects such as firearms law and ballistics, National Parks law, flora and fauna, first aid, and photography. At the end of the training period, there is a week's evaluation in the bush with experienced examiners, which includes work on a shooting range and sometimes even

hunting big game, if the examiners feel this is necessary. The license is well-respected, and earning it is serious business: each guide knows he is being entrusted with the lives of his clients.

It was natural that Humphrey would be the lead guide on our canoe trip. A member of the Tonga tribe, he was born in the small lakeside town of Kariba and had to learn about the

Humphrey resting, ink and watercolor on cold press paper, 2006

Humphrey and canoe, charcoal on cold press paper, 2005

water and the wild at a very young age. He was swimming from the age of five, and participated in various wildlife conservation and survival courses when he was in primary school. Although not many Africans are this fortunate, Humphrey was sent to a boarding high school at age 12, not only to further his education, but to build character. Rather than go on to college, he decided to pursue a career in conservation and safari guiding. After attaining his learner's license, he went on to intensive guide training and obtained his river guiding and walking licenses before he achieved the level of professional guide in 2001.

A member of Botswana's Bakwena tribe, Thompson, our guide at Little Mambo, was

born not far from the camp in the village of Molepolole. His father was a miner and his mother a schoolteacher; Thompson and his three brothers were raised in the small mining town of Orapa. Because at that time (the late 1960s) Botswana had one of the poorest and least educated populations in the world, there were many expatriate staff at the mine, with their families residing in the same town. Thompson, therefore, had the unusual experience of being exposed to 22 different nationalities when he was young. Like Humphrey, Thompson was sent to high school in the nation's capital, Gaborone, when he was 12, where there were 600 children representing 46 different nationalities. After graduation, he taught primary school as part of a community service requirement before joining the work force in Gaborone, while at the same time studying marketing and business. Thompson continued to yearn for his homeland, however, and in 1996 he returned to the Okavango Delta and entered the tourism field, working his way up from barman to manager. He became a licensed professional guide in 1998.

Like all of our guides, Humphrey and Thompson had the primary goal of making sure we were protected, and they went out of their way to ensure we saw everything we wanted to see. Very unassuming and happy with what little they have (when compared to those living in the Western world), their outlook is to be admired and emulated. Thanks to these skilled guides, my African experience was everything I had ever dreamed of—and more.

In general, this mock charge tactic is designed to intimidate—and it usually succeeds if you are not mentally prepared. This young bull certainly scared me. It drummed home the importance of listening to your guide. My instinct would have been to run like mad. Who wouldn't feel that way? But no one can outrun an elephant. The best thing to do is stand your ground, so listening to my guide, who was very knowledgeable and well trained, was the best thing I could have done.

BIG SIX

Just as an entire painting can change when one stroke is added, the Zambezi is ever changing, largely due to fluctuations in the water level caused by the Kariba Dam upstream. Erosion alters the river's entire course; new channels open where dry land had existed, and what were once deep channels where you could take a swim become filled with sand. Therefore, there is no specific route to the Mana Canoe Trail; it varies depending on the season and where the wildlife is congregating.

Hippo, ink and watercolor on rice paper, 2005

As we headed off down the river, our canoes powered by the surge of adrenaline we all felt after our elephant encounter, we hit a patch of deep water, which is a favored hippo habitat. Knowing this, our guides continually tapped the sides of their canoes with their paddles as a warning to any huge creature that might be traveling underwater beneath us. During our canoe orientation, we had been cautioned to always avoid hippos entering the water from the shoreline and to beware of hippos onshore grazing or even relaxing. Their passive appearance when resting in the water or grazing on land belies a potential for ferocious aggression—so much so that the hippo has now been added to the "Big Five," making it now the "Big Six." Said to be responsible for more human deaths than any other African animal, the extremely dangerous hippo is noted for its short temper and will not hesitate to charge. You definitely don't want to be on the receiving end. The mouth and teeth of these massive animals are the largest in the world: scissorlike canines up to 20 inches long in front, with crushing, grinding molars in the rear. During a fight, male hippos ram each other with their mouths open, using their heads as deadly sledgehammers.

As we continued downstream to that evening's campsite, our guide noticed hippos up ahead and told us to watch, in particular, one that was on the right shoreline. The beast meandered parallel to us for a while and I was able to take some good photos. Then suddenly, without warning, he took an abrupt left and came charging into the river—fast. "Back paddle, back paddle, back paddle!" yelled our guide. It all happened very quickly. Our shocked reactions and the wake created by the hippo caused our canoes to roll sharply from side to side. My camera still in hand, I was now taking photos of the sky, the river, and, I hoped, the hippo. I felt utterly helpless as three tons of dangerous animal moved toward my canoe at high speed, a massive blur of a giant, with colors ranging from deep gray to crimson. Water splashed on me as he passed in front of the canoe by only feet, casting an angry look in our direction—another reminder that we were only temporary guests in this magical land.

AFRICAN WINGED WILDLIFE

Although I had come eagerly anticipating the wildlife I was now encountering on this safari, I was also impressed with the remarkable bird life. Along the banks of the Zambezi, in fact, flourishes one of the greatest varieties of bird life in the world—more than 380 species. The riverbanks flutter with Goliath herons, Egyptian and spurwing geese, cormorants, storks, and brilliantly colored bee-eaters and kingfishers. Most impressive to me were the ubiquitous weaver birds (Ploceidae family) and the regal fish eagle (*Haliaeetus vocifer*).

Often boasting bright yellow plumage, the little weaver birds make intricate and conspicuous nests in acacia trees near the river's edge, their colonies of delicate woven homes hanging precariously over the water. By contrast, the fish eagles' nests are large and untidy and usually built in the branches of bare trees.

This large bird's white head, black upper parts, and chestnut under parts call to mind our own American bald eagle. As its name implies, the fish eagle feeds mainly on fish caught in its talons during dramatic shallow dives from perches beside the water. The bird's call, often uttered on the wing in duet between members of a pair, is probably its most distinctive feature, a piercing cry that rises and falls in pitch and volume.

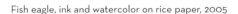

Fish eagle, ink and watercolor on rice paper, 2005

Lesser weaver bird with nest, dye on silk, 2005

AN ELAND SIGHTING

As we pulled into shore that evening, I was impressed to see an eland (*Taurotragus oryx*) standing on the bank. Prolific in East Africa, this largest of the African antelopes is rarer on this part of the continent, and we hadn't seen any up to this point—probably because this huge, oxlike animal is timid. Elands are usually found in bush country, where they use their prominent, spiral horns to break off branches beyond the reach of their jaws and their front hooves to dig up roots and tubers. Nature has given the eland a unique way of coping with extremes of hot and cold; not only does it rarely drink, but it conserves moisture by not sweating, allowing its body temperature to rise slightly during the day. In spite of its great size (up to six feet high and weighing up to 2,000 pounds), this gentle giant can walk faster than a man, gallop at great speed for short distances, and leap gracefully over fences up to six feet high. Although elands are gregarious and can be found in groups of up to 100, bulls, like the one we saw this evening, are often solitary. He gazed at us briefly before trotting away to safety in the bush. It was a peaceful ending to what had been a very eventful day.

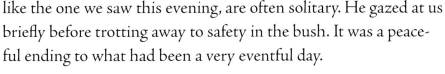

Eland, ink and watercolor on rice paper, 2006

AN EXCITING FINALE

It was early morning, about seven o'clock, and we had just finished breakfast. Looking through his binoculars, our guide spotted a pair of wild dogs crossing the landscape near the camp. "Let's go!" he shouted. Thus began a memorable two-and-a-half-hour trek through the African bush.

THE AFRICAN WILD DOG

The African wild dog (*Lycaon pictus*), or painted hunting dog, was once common in Africa, with a population over 500,000 throughout 39 countries. Sadly, the effects of human encroachment and disease have drastically reduced their range and numbers. The most severe threat to the wild dog is its mostly undeserved reputation as a voracious killer of game and livestock, which has led to its widespread persecution.

AFRICAN WILD DOG (*Lycaon pictus*)

MARKINGS: The coat of the wild dog (also known as the hunting dog) is a mottled combination of yellow, brown, white, and black in random patterns unique to each animal. Tail tip is white; ears are large and rounded without distinct tips.

SIZE: Animals weigh up to about 60 pounds, are approximately three-and-a-half feet long, and stand about two-and-a-half feet tall.

BEHAVIOR: Wild dogs are only found in packs of a minimum of four animals but sometimes as many as 40. Dominant animals may occur within a pack, but generally there is no hierarchy, with food shared among all members. The wild dog hunts by sight in packs; they are one of the most skillful hunters of Africa. The dog will howl softly, repeating up to six times and carrying for some distance, to rally a pack.

GESTATION: Just over two months, with two to 16 pups born in a burrow lined with grass. Two females in close company may use the same burrow. The young become fully apprenticed hunters at the tender age of six months.

LIFE SPAN: 10 to 12 years.

PREDATORS AND PREY: Hyenas and eagles will prey on unguarded pups. Wild dogs will hunt mostly medium-sized antelopes and gazelles. The pack first follows the selected prey at a trot; within five to ten minutes this changes to an all-out race, up to 35 mph. By taking turns in the lead and cutting off corners, the pack overtakes the prey, brings it down by a bite in the groin. Within minutes it is torn to pieces and devoured by the pack. An adult animal's food requirement is six to 12 pounds of meat daily.

DEFENSE: Numbers and skillful hunting techniques.

CONSERVATION: Once prolific throughout Africa, the wild dog is an endangered species, with only about 3,000 animals remaining in four African countries: Tanzania, Zimbabwe, Botswana, and South Africa. The reduction in population is largely attributed to encroachment of humans, as well as disease.

Wild dog, ink and watercolor on rice paper, 2005

In most of Africa, wild dogs are shot or poisoned, usually by ranchers and farmers who want to protect their livestock. In addition, the wild dog's habitat has been shrinking as human populations expand, leading the animal into increased contact with humans, their domestic animals, and the diseases they carry. The wild dog appears to be susceptible to many diseases—particularly canine distemper, rabies, and anthrax—which can spread easily and rapidly through a pack. Currently an estimated 3,000 dogs remain, restricted to four African countries: Tanzania, Zimbabwe, Botswana, and South Africa. Time is running out for this endangered species, and our guide explained that coming upon them in the wild would truly be a special privilege and a fascinating experience.

The African wild dog's coat is unmistakable: a combination of yellow, brown, white, and black in random patterns unique to each animal. The dogs hunt skillfully, as a pack, running at an average speed of 35 miles an hour for more than three miles and chasing prey as large as a wildebeest. The wild dog is one of the most successful hunters, second only to the crocodile, catching its prey up to 90 percent of the time. Members of the pack will sometimes feed on the prey while it is still alive, returning to the den to regurgitate the meat for their pups to feed upon.

Wild dogs are social, living in small cohesive packs typically composed of a dominant breeding pair, a number of nonbreeding adults, and their dependent offspring. Within the wild dog pack all the males are related to one another, and all the females to each other but not to the males. Females migrate into the pack, whereas males usually stay with their natal pack. Normally, only the highest-ranking male and female breed. These predators hunt whenever and wherever the opportunity presents itself, but often at dusk or in the early morning, which is probably why the dogs our guide spotted were on the move.

Wild dog track, ink wash on rice paper, 2005

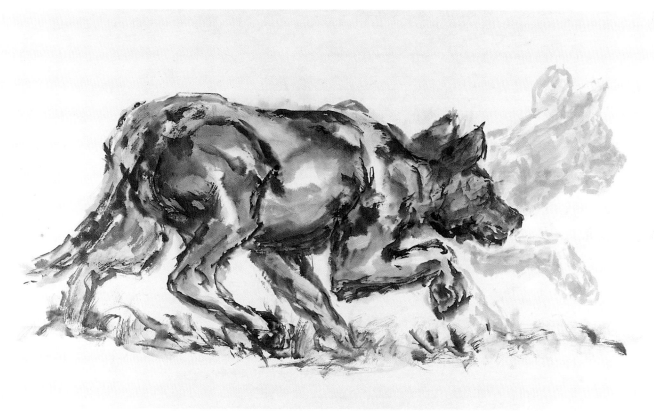

Wild dogs pursuing prey, ink and watercolor on rice paper, 2005

We lost the wild dogs temporarily when we were tracking them, but then we saw some spotted hyenas. Our guide immediately instructed me to move towards the hyenas, because the hyenas will follow the wild dogs, knowing they will kill something the hyenas can feed on later. If the hyenas ran from me as I approached, he would know they weren't following the wild dogs; if they didn't look at me, we would continue to follow the hyenas. Africa is full of symbiotic relationships such as this— all creatures are following something else because they know there's a meal in it for them. I went to check out what the hyenas were up to and got within 30 yards of the somewhat creepy creatures.

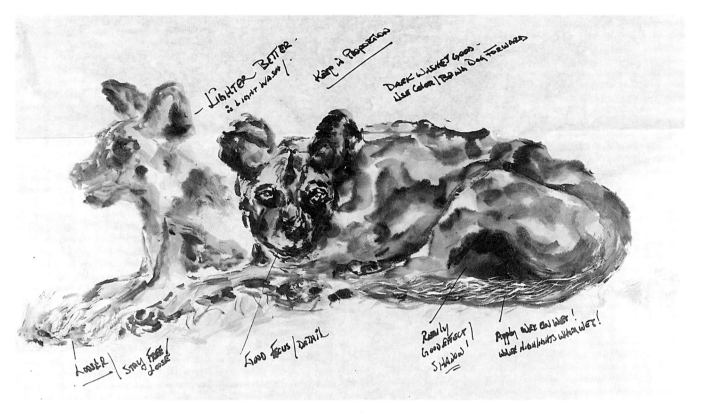

Wild dogs, ink and watercolor on rice paper, 2005

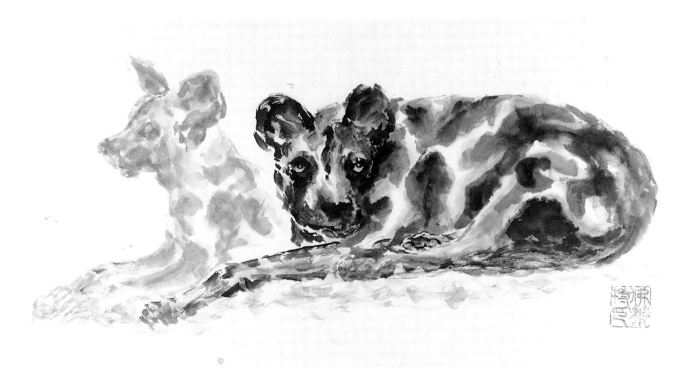

Wild dogs, ink and watercolor on rice paper, 2005

SPOTTED HYENAS

Spotted hyenas (*Crocuta crocuta*) are hunters as well as scavengers, mostly hunting in small packs of two to five. Hyenas have been clocked at up to 40 miles per hour and can easily chase down a weak, very old, or very young gazelle, Cape buffalo, giraffe, or wart hog. Their jaw muscles are very powerful because of their diet, which includes bones, horns, and even hooves of almost any dead animal. Hyenas kill their prey by tearing it apart, usually severing the main arteries in the neck first. Unsure of when they will eat again, hyenas gorge themselves whenever possible, eating up to one-third their body weight or more, which equates to 30 or 40 pounds of meat for an adult.

SPOTTED HYENA *(Crocuta crocuta)*

MARKINGS: Whitish-grey to yellowish-red body covered with irregular dark brown to black spots about the size of a penny. Massive and powerful head and sturdy muzzle with medium-sized round ears and sloping back, with a bushy tail.

SIZE: Females are one-fifth bigger and heavier than males, weighing in at a maximum of 190 pounds, six feet long, and three feet high.

BEHAVIOR: Usually in pairs, family parties, or troops, sleeping in burrows by day and scavenging or hunting at dusk and night. Matriarchal society that is very territorial, with the homeland constantly guarded and patrolled and enemy packs chased out. Very vocal, with up to 17 different sounds, including a succession of howling screams to indicate gathering for the evening hunt. When a hunt is successful, maniacal laughterlike sounds, the stereotypical sounds of the hyena. The animal's chief food is carrion, often from lion kills. Hyenas have the most powerful jaws in the animal kingdom: they devour all parts of the carcass, including skin, hair, and bones.

GESTATION: Just over four months, with a litter of one to two pups, rarely three.

LIFE SPAN: Up to 40 years recorded in captivity, around 20 in the wild.

PREDATORS AND PREY: Single animals may be killed by lions or hunting dogs; young pups are sometimes attacked by old male hyenas and strange packs. Hyena prey include gazelles, antelopes, and zebras, the chosen victim being brought down by a bite on the fetlock and torn to pieces while still alive. Young, sick, and old animals are seized.

DEFENSE: Strong jaws, speed (up to 55 mph), and safety in numbers. Mothers will defend their pups bravely against any enemy.

INTERESTING FACT: The external genitalia of the female hyena is superficially similar to that of the male, leading to the popular misconception that the animal is a hermaphrodite.

CONSERVATION: Spotted hyenas are not immediately threatened or endangered. However, their continued existence, as is true with all predators, depends upon the availability of prey. As human expansion continues to demand more space, there is inevitably less space left for prey animals. Since the number of predators is strictly dependent on the number of prey available, the long-range consequence will be a reduction in the numbers of all animals.

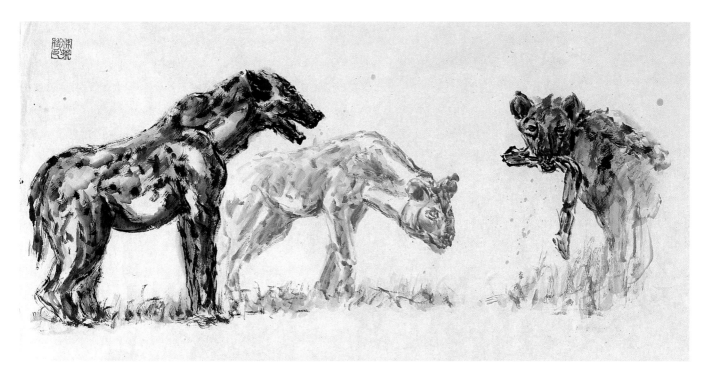

Spotted hyena, ink and watercolor on rice paper, 2005

Hyenas often steal kills from cheetahs and leopards, while lions will steal from the hyenas. The African lion and the hyena, in fact, are ferocious enemies, often putting up boundaries against each other. They not only threaten each other but attack without being provoked. A pack of hyenas can easily take down a lioness, and they will kill unprotected lion cubs. Adult lions, in turn, kill hyena adults and juveniles; the lion is the only known natural predator of the hyena.

The hyena is a very noisy creature; its sounds are characteristic of the African bush. Scientists have recorded up to 17 different sounds, including a succession of howling screams that indicate gathering for the evening hunt, blood-curdling "laughter" when the hunt is successful, and high screams of anger when the hyena is trying to drive off lions or other packs from its prey.

Interestingly, there exists a myth that hyenas are hermaphrodites. In fact, the females have more testosterone in their bodies than do the males, making them heavier, more muscular, and more aggressive. To further fuel the hermaphrodite myth, the female genitalia have a superficial similarity to those of the male.

This morning, the hyenas weren't in the least bothered by my presence, so we suspected they were indeed after the wild dogs. We continued to follow them in the hope that they would lead us to what we wanted to see.

CAPE BUFFALO

As we pressed on, off in the distance, about 200 yards away, we noticed a large black rectangular object with a massive cloud of dust surrounding it, and it was headed towards us. Before I was even able to ask our guide what it was, he told us to follow him. Here we were, standing in a clearing, without cover, tracking the elusive wild dogs, and suddenly it became apparent that the "object" coming rapidly in our direction was in fact a stampeding herd of Cape buffalo.

The African, or Cape, buffalo (*Syncerus caffer*) is often mistakenly called a "water buffalo," which in fact is a different species of buffalo found largely on the Asian continent. There are two subspecies of Cape buffalo: the smaller forest species and the larger savanna species, which can stand nearly six feet tall and weigh up to 2,000 pounds. The horn span of a large bull can exceed three feet. When grazing like any domestic cattle might, Cape buffalo seem quite docile, but they have been placed in the "Big Six" category for a reason. These creatures can be aggressive, powerful, and fast, running at speeds up to 35 miles per hour. It is said that more big game hunters have been killed by buffalo than by any other African animal; when wounded, the animals are even reputed to stalk and attack the hunter. Solitary males are the most aggressive and dangerous, particularly if they are older.

This herd, like most Cape buffalo herds, had bulls as leaders and guards: one at the front, one at the rear, and several side guards, with the cows and calves in the middle of the group. Herds of up to 2,000 have been reported; this one was probably only 100, but it was formidable enough for me.

Cape buffalo, ink and watercolor on rice paper, 2005

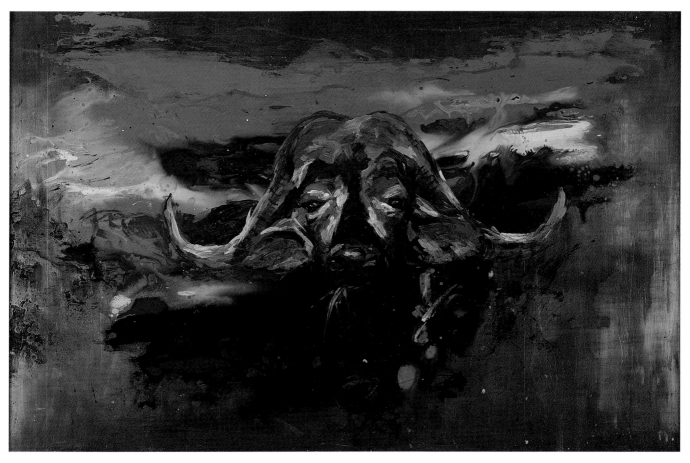

Cape buffalo, oil on copper, 38 x 26 in., 2005

CAPE BUFFALO *(Syncerus caffer)*

MARKINGS: Red to dark brown animals, with both sexes having horns, sometimes formidable, projecting laterally with tips curved upwards and inwards. The horn span of a large bull can reach three feet.

SIZE: The larger savanna species can stand nearly six feet tall and weigh up to 2,000 pounds; forest species somewhat smaller.

BEHAVIOR: Like many plains animals, buffalo rest during the heat of the day and are more active at other times. Herds of between 20 and 2,000 have been reported; a basic herd consists of females with young up to three years old. Males often form bachelor groups within or outside of the large herd. Males past the age of ten are usually solitary and can be mean if provoked. Buffalos generally eat grass, and because they need to drink daily, they are often not far from water.

GESTATION: 12 months, with one young; twins very rarely.

LIFE SPAN: About 20 years in the wild; up to 26 in captivity.

PREDATORS: Principally lions, who prefer to attack calves and solitary animals. When in water, buffalos also face danger from crocodiles. Calves are also at risk from hyenas.

DEFENSE: Buffalos defend themselves and their calves courageously, usually by charging and doing damage with their often massive horns. They can reach speeds of up to 35 mph and can be very aggressive. A solitary, old animal will, if provoked, ambush men; when wounded, they are even reputed to stalk and attack a hunter.

CONSERVATION: Competition for food sources from domestic livestock is a threat facing grazers like Cape buffalos. But an even greater danger is the introduction of foreign diseases from nonnative species. Bovine tuberculosis can decimate the herds of Cape buffalo, as well as their prey species.

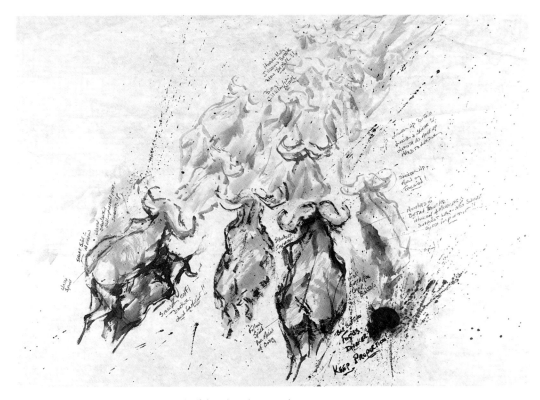

Cape buffalo, ink and watercolor on rice paper, 2005

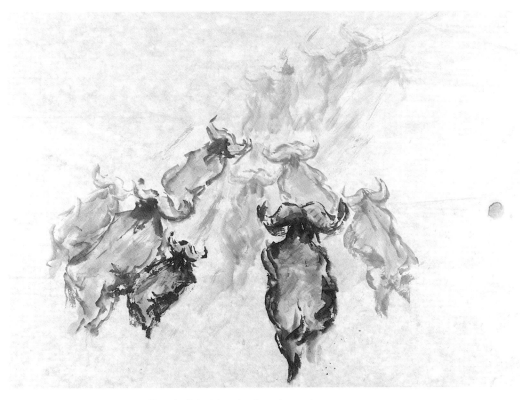

Cape buffalo, ink and watercolor on rice paper, 2005

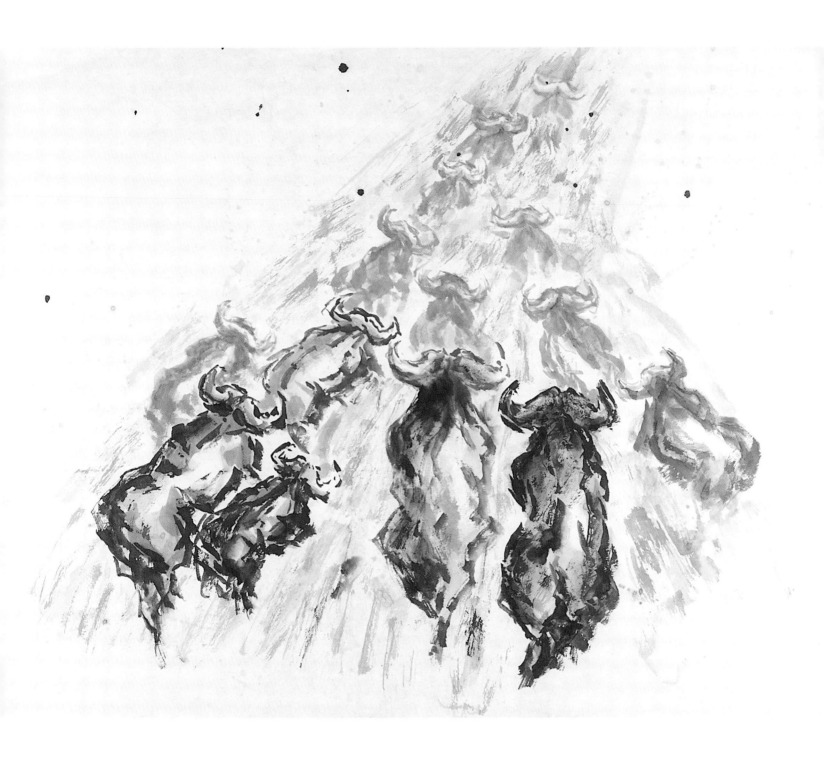

Cape buffalo, ink and watercolor on rice paper, 2005

Our guide quickly steered our little group to a fallen acacia tree, probably pushed down by an elephant some time ago. It had few limbs remaining and really was no more than an average-sized tree trunk lying on the ground. In order for it to provide any cover at all for us, we would have to get down behind it on our hands and knees, or even lower onto our bellies.

As the herd got within 100 yards of us, the leader and several other bulls near him stopped suddenly, and their noses went up in the air, sniffing out any possible danger. They knew we were there. The large, old bull at the head of the herd perused the landscape ahead. Then something spooked them, and they were off and running again. They were moving fast, right toward us. The sound of the hooves pounding the land was like that of an approaching locomotive; the dust kicked up was thick and reminded me of a sandstorm over the Arizona desert.

I edged back from the tree trunk momentarily to get a photo of the members of our party crouched and hiding from the oncoming wall of buffalo, but I was stopped short by our guide, who ordered, "Get back under cover *now!*" At this point the herd was only about 30 yards away and showed no sign of slowing down. They ran with their heads held lower than their shoulders; their horns sat like huge helmets on their foreheads. Twenty yards away; I could see their noses glisten against the backdrop of their black chests, their eyes dark and menacing. I remember looking at our guide and thinking, "How many bullets do you have? Two? That's not enough!" Within ten feet of the trunk where we were hiding, they suddenly stopped, turned, and reversed course. We were able to breathe again.

When this day began, we had intended to be in the canoes at seven o'clock.; it was now noon. But that is one of the most wonderful things about this type of safari: it was totally unscripted and flexible, allowing for the spontaneity to follow the exciting and unpredictable adventures of nature.

We headed down the river again, pulling over at one point, and our guides instructed us to get out of our canoes and enjoy lunch at a table they had set up in the water, on a sand bar right in the middle of this mile-wide river. Eyeing the hippos and crocodiles about 100 yards away, I was dubious at first. After reassurances from the guides, I got out and enjoyed the unusual lunch setting, complete with champagne.

FOOD ON SAFARI

When one thinks of Africa, a gourmet meal is hardly the first thing that comes to mind, but safari-goers are in for a pleasant surprise. Amazingly, much of the continent is a veritable Garden of Eden, where a seed dropped on the ground will grow. There are abundant fresh fruit and vegetables, as well as savory meat and poultry untainted by additives, steroids, and preservatives now so common in our Western world. Even in the simplest set-ups, such as our temporary camps along the Zambezi River, we were treated to delicious home-baked bread and rolls, home-made soups, and tasty main courses. The more permanent camps put on unbelievable spreads for breakfast, lunch, and dinner; sometimes beautifully presented buffets overflowing with a bountiful array of food that even the pickiest eater couldn't fault.

Yes, we did try crocodile meat once (at the touristy Victoria Falls; tastes like chicken!), but in general the food we ate was familiar, such as lamb with carrots and potatoes, barbecue chicken and scalloped potatoes, duck, steak with leeks and cheese, and—one of my personal favorites—oxtail stew. I liked it so much, I even wrangled the recipe from the camp cook.

OXTAIL STEW

INGREDIENTS:
2 onions, finely chopped
2 stalks celery, finely chopped
1 carrot, finely chopped
2 cloves garlic, finely chopped
9 lbs. oxtail, prepared by butcher
1 pint red wine
1 can of beer
1 pint of beef stock
2 bay leaves
2 sprigs parsley
2 sprigs thyme

PREPARATION:
In large saucepan, sauté onion, celery, carrot, and garlic over a low heat until cooked. Meanwhile, coat the oxtail in flour and brown in separate pan. Add oxtail to the onion mixture, and then add the red wine, beer and beef stock until the oxtail is just covered. Add the bay leaves, parsley, and thyme. Simmer over a low heat for two to six hours or until the meat is very tender (falls off the bone). Thicken the sauce to desired thickness by cooking over high heat until reduced, or adding small amount of cornstarch/water mix (slurry).

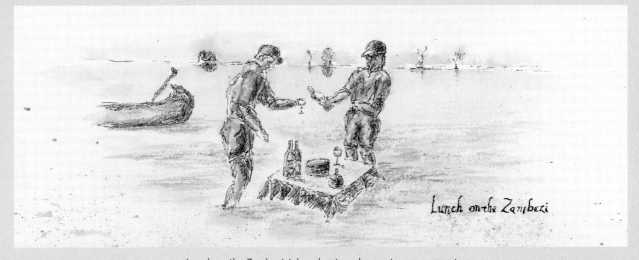

Lunch on the Zambezi, ink and watercolor on rice paper, 2006

THE NILE CROCODILE

The Zambezi has a healthy population of the Nile crocodile (*Crocodylus niloticus*), the best known of all the crocodile species. It is feared as a great man-killer, and its large, stocky body, eerily reminiscent of the age of the dinosaurs, doesn't help its reputation. Nile crocodiles have a maximum length of 20 feet and can weigh up to 1,650 pounds. Though they spend much of the day basking on sand banks, these giant lizards are often shy, slipping quietly into the water when humans approach and staying submerged for long periods. Large crocodiles will prey on animals as large as antelopes

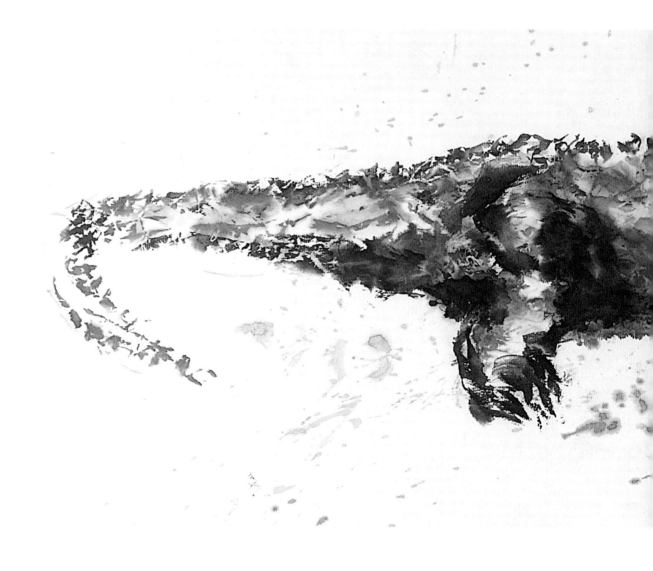

and even buffalo, launching an extremely rapid attack on their prey as it drinks or swims and then pulling it underwater until the quarry drowns. The crocodile's eyes, ears, and nostrils are found on the same plane on the top of the head, allowing it to be completely submerged underwater while still being able to see, smell, and hear—*and* allowing it to swim nearby virtually unnoticed by other animals or unsuspecting humans. I was ever aware of these bastions of the dinosaur age as we dined, somewhat nervously, at our floating tables.

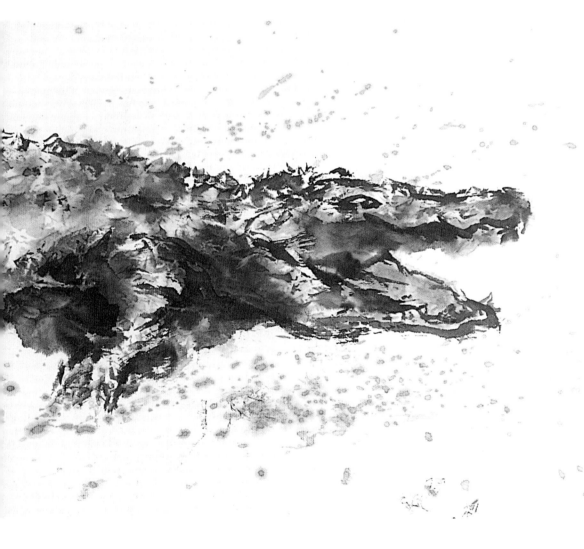

Crocodile, ink and watercolor on rice paper, 2005

T

There is always something new out of Africa.

—PLINY THE ELDER, AUTHOR

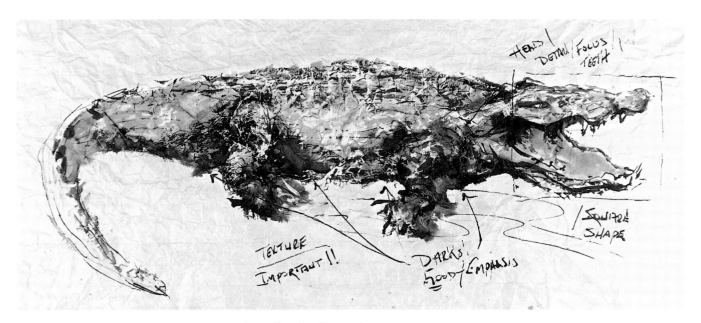

Crocodile, ink and watercolor on rice paper, 2005

THE DEFASSA WATERBUCK

After lunch we continued down the river, savoring what we knew was our last stretch of the Zambezi. At one point, the river went one way but our guide steered us over to a little delta to the right. Grass and water lilies surrounded us; we saw waterbuck on one bank. As its name indicates, the Defassa (or common) waterbuck is usually found near water. Only the males have horns, which they use to defend themselves; sometimes they even take to the water or hide in reeds submerged up to the nose. The waterbuck's only real enemies are lions, leopards, and hunting dogs, although even they will leave the animal alone if there is enough other game in the area, because its flesh is tough and stringy, rank and musty scented (like turpentine).

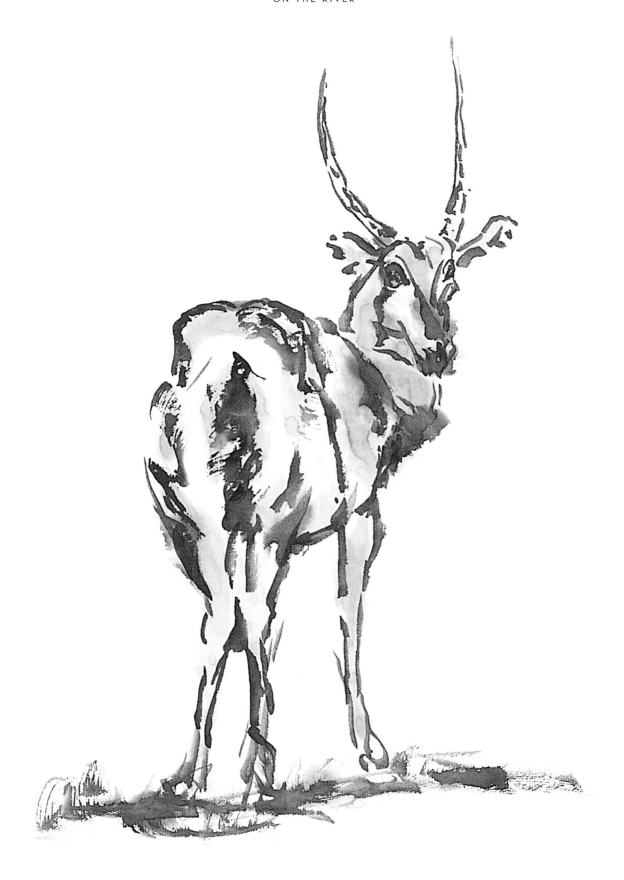

Defassa waterbuck, ink and watercolor on rice paper, 2005

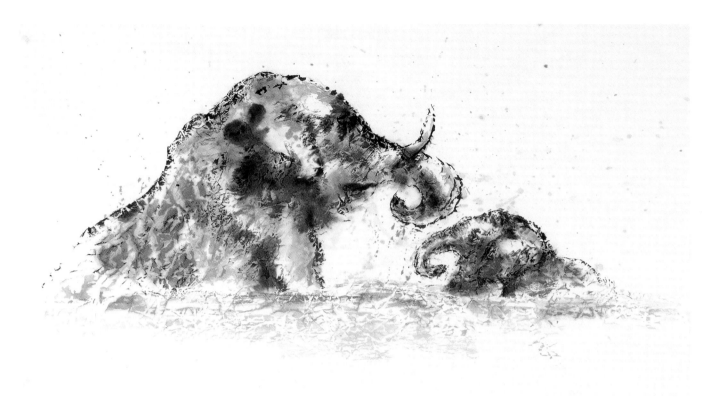

Elephants at watering hole, ink and watercolor on rice paper, 2006

THE GENTLE GIANT

In the near distance, we noticed a number of elephants belly high in the green, lush fauna of the river. Slowly we approached them. There were two baby elephants on the right; the elephant that appeared to be their mother was on our left. Elephant twins are extremely rare. Our guide told us to stop paddling, and although we moved at a snail's pace, the river's current still carried us toward them. He pulled his canoe alongside ours and grabbed it, trying to back paddle.

Elephants have a matriarchal clan society, the basic units consisting of a mother with her dependent offspring and grown daughters with their offspring. Males live separately, alone or in bachelor herds. A herd's welfare depends on the matriarch's leadership; she sets its direction and pace and the rest of the herd follows, spreading out and feeding when she feeds. When the herd is disturbed, its members cluster around the matriarch (the biggest cow), with calves in the middle. Whether they flee or charge is up to her. If something happens to her, for example, if she gets shot, the rest, rather than abandoning her, will usually stay and therefore get shot as well.

Elephants have a very social interaction with each other; there are "midwives" to help with births, "nannies" to look after the young, and "nurses" who look after the sick. Perhaps the most touching proof of the cooperative nature of elephant society is that they attempt to raise and support a fallen group member, one on each side. Since calves and young animals learn from their elders all the important details of living, the overshooting or culling of old tuskers can have a harmful effect on the behavior of the species. If an elephant dies, a companion will remain on watch by the body (a cow may drag off the body of her small calf for a whole day), often covering the corpse with branches. The elephant has even been known to do this to a human corpse.

Although elephant births occur year round, researchers have found a correlation between the main rainy season and the maximum breeding time. Elephants can first conceive at the age of ten or 11; gestation is 22 months, with an interval of four to nine years between calves. The tender, loving care lavished on baby elephants is one of the species's more endearing traits, and it is always amazing to think of how these huge beasts avoid stepping on the tiny creature at their feet. Adults remain in constant touch with calves small enough to walk under their mothers (within the first year); if one strays more than 20 yards away, the mother or a nanny will retrieve it. Closely related females cross-suckle each other's calves; some cows keep lactating indefinitely. The bond between mother and daughter lasts for up to 50 years.

The two youngsters we watched in the river seemed to be alone with their mother, and we did not want to get between them. The mother was chest-high in the water, eating, and it was unlikely that she would charge. I was so close that I could see my reflection in her eye; I could have reached out and touched her with no effort. She continued to graze, although she was very aware of us. The babies were closer to shore, with a distance of about 30 yards between them. We continued to drift, and our guide continued to back paddle, but we were getting very close to the mother. When I was within five feet of her, I looked at her and could see her looking at me. Suddenly she took a bite of grass, looked me right in the eye, lifted her trunk, and turned it toward me. With her keen sense of smell, she began sniffing my body and casually let her nose drift around my head, only inches from my face. I held my breath. I could smell her and the grass and dirt she was eating. I could see the pink-

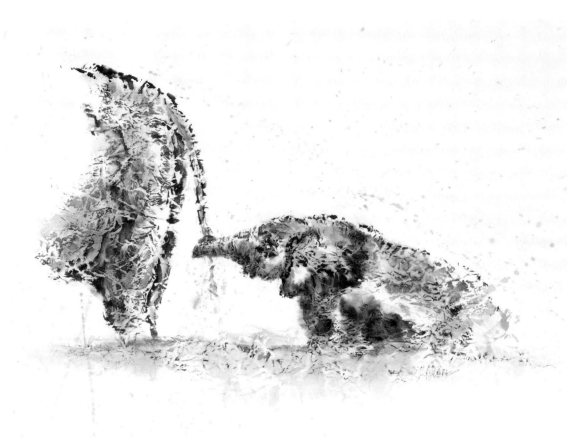

Elephants at watering hole, ink and watercolor on rice paper, 2006

ish-white of her trunk, the droplets of water dripping off her nostrils. Apparently satisfied there was no danger present, she dropped her trunk back into the water and moved across our path to her infants, gathering them to her and retreating to the shoreline. As they emerged from the water, they all looked two-toned: a light gray on the top half and darker charcoal gray below. When she got about 30 feet away from us, the mother turned, fanned her ears at us, as if she was saying, "We are leaving now," and meandered away.

It was a touching ending to an amazing journey down one of Africa's mightiest rivers. We had time for a short hike the next morning before boarding a small plane and flying to a point some 50 miles away, where the Zambezi plunges over the Victoria Falls. Twice the height and one-and-a-half times the width of America's Niagara Falls, the great wall of water is impressive, but my focus remained on the continent's wondrous wildlife and what excitement awaited us during the next leg of our unforgettable African adventure.

God made the world round so we would never be able to see too far down the road.

—ISAK DINESEN, AUTHOR

Elephants leaving watering hole, charcoal on cold press paper, 2005

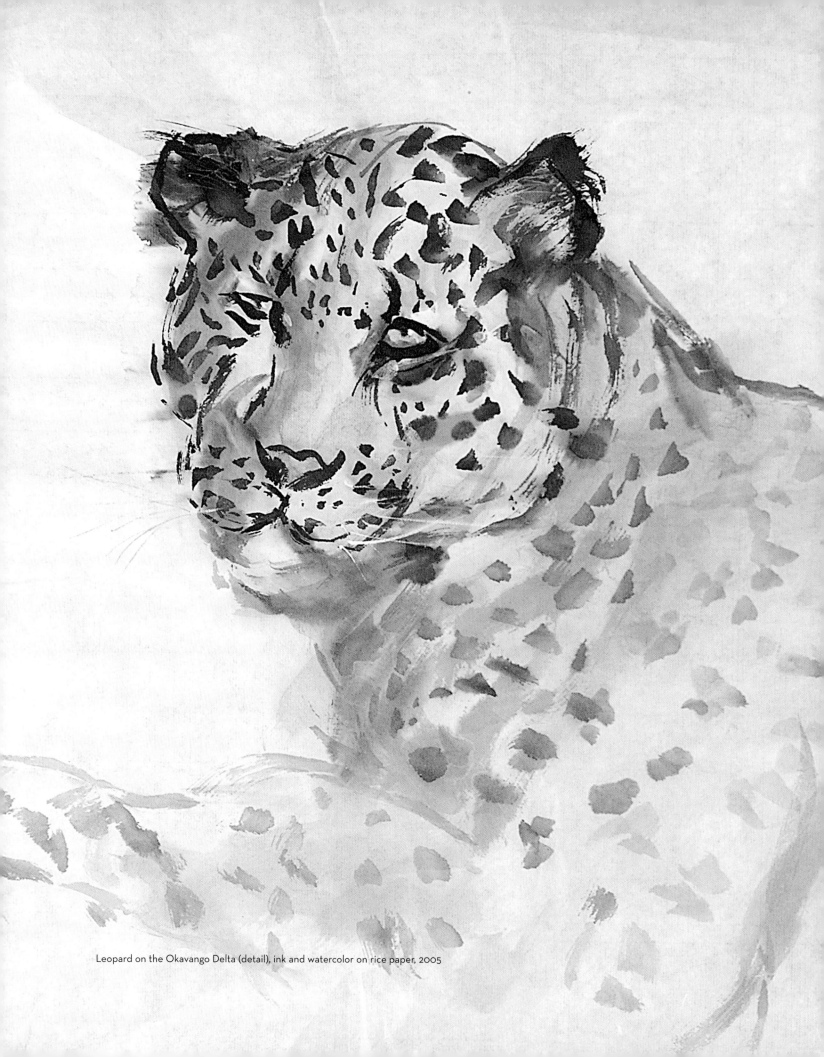

Leopard on the Okavango Delta (detail), ink and watercolor on rice paper, 2005

On the Plains

Good-bye Zimbabwe, hello Botswana. We flew by light charter aircraft into this landlocked country, sandwiched between South Africa, Namibia, Zambia, and Zimbabwe, right in the heart of southern Africa.

Botswana achieved its independence in 1966, and it was a timely one: immediately afterward three of the world's richest diamond-bearing formations were discovered there. This is a country for the intrepid traveler, largely a roadless wilderness of vast spaces—savanna, desert, wetland, and saltpans. Botswana's diamonds are not its only asset; the country is also rich in game, artistic tradition, and natural appeal, creating a need to preserve that which Botswana has to offer while still acknowledging the benefits afforded by tourism. The government's response to this challenge has been to court only high-cost, low-impact tourism, which has succeeded in keeping the country wild and wonderful rather than teeming with visitors.

SAVUTI CAMP

Our home for the next three nights was Savuti Camp, located in the Linyanti Reserve along the Savuti Channel in the northern part of Botswana. The channel itself stopped flowing in 1980 after a seismic tremor, turning what was once a hippo-filled river

Impala drinking, charcoal on cold press paper, 2005

into wide, open grasslands. What was previously a lush haven for herbivores became an arid environment, but one of the best places in the country to view predators and the game of the plains.

We made our way from the airstrip to Savuti Camp in our Land Rover. There would be no foot safaris here, a result of the Botswana government's desire to protect the environment and concern for the safety of tourists. Dusk approached as we got nearer to the camp, but we postponed dinner when we spotted a female leopard loping through the brush. We stopped to watch this spectacular animal, the third of the Big Five we had the good fortune to observe. Her golden coat, with its distinctive black rosette markings, glistened against the backdrop of the setting sun.

THE LEOPARD

The leopard (*Panthera pardus*) is not the largest of the African cats, weighing in at a maximum of 200 pounds for a male and about two-thirds that for a female. But what it lacks in size it makes up for in muscle and skill; it can easily take down mammals, including predators, up to the size of a small antelope, and sometimes also larger antelopes, lion cubs, young apes and baboons, and domestic stock (sheep, goats, calves, poultry), as well as any birds up to the size of a stork. The leopard's snacks can include snakes, tortoises, fish, and insects, though domestic dogs and all monkeys are particular favorites. If undisturbed, leopards are active by day and night, but where hunted they remain very secretive and nocturnal. A leopard's sight and sense of smell are good, but its hearing is exceptional.

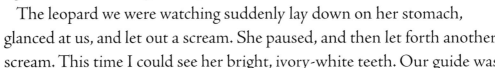

Leopard track, ink wash
on rice paper, 2005

The leopard we were watching suddenly lay down on her stomach, glanced at us, and let out a scream. She paused, and then let forth another scream. This time I could see her bright, ivory-white teeth. Our guide was puzzled: were we too close, or was she calling to another? She let loose a third scream. From the underbrush almost 20 yards away we heard a barely discernible yelp. Without warning, a small head emerged and released a second yelp. Several seconds passed before the mother again screamed, apparently letting her cub know all was clear. With that assurance, the cub began running as fast as it could, legs scrambling to

Leopard at watering hole with track, charcoal on cold press paper, 2005

keep up with its anxiousness, toward his mother, who was lying very still, watching her cub intently. Much to our amazement, as the cub approached, the mother opened up her arms to receive it. In turn, the cub leaped at her with open arms, clasping its paws around her neck. As its mother lifted herself up, the cub just dangled there, licking her face from side to side. She responded with a purr. The emotional connection between these two reached out and touched all of us.

Playfulness and affection are common between a leopard and her cubs. The mother usually has one to three cubs at a time, which, for the first few months, she carefully hides in a cave, a rock pile, or a clump of bushes. But to find and catch food, she has to be away from the cubs almost half the time, sometimes for more than a

Ndebele house, ink and watercolor on cold press paper, 2006

THE PEOPLE

The men and women who call Zimbabwe and Botswana home are sturdy but gentle folk, many of them stemming from the great family of Bantu-speaking migrants who first ventured east and south across Africa some 2,000 years ago. Most are not urban-dwellers; their cultures are firmly rooted in the soil and, even if they do have to go into the cities for their education or their work, they seldom forget their rural roots.

In both countries, the traditional rural homestead remains much the same as it was for hundreds of years—usually a round mud and thatch hut with baked earth floors constantly swept clean by the house-proud womenfolk. Two or three such homes are built together in a compound, with an open fireplace at its center and some sort of wall (made of either mud or thorny branches) surrounding it to protect the people and their livestock from the threat of attack by wildlife. Some houses are made in a newer style, square with metal roofs, while in Botswana's northwest some are made of reeds.

The biggest percentage (just over 80 percent) of Zimbabwe's 13 million people belong to the Shona group, who live in the northern and eastern parts of the country, followed by the Ndebele, who mainly inhabit the south-

The earth is a beehive; we all enter by the same door but live in different cells.

—AFRICAN PROVERB

west. English is the official language, and many speak it, although the two prominent Bantu languages of Shona and Ndebele are also widely spoken. The Shona are known the world over for their beautiful stone sculpture. They use primitive hand tools and skills handed down through the generations to craft indigenous stones, such as serpentine, verdite, opal, and springstone, into works of art. They often depict relationships between families and couples, both human and in the animal kingdom, largely because of the strong Shona ties to family and tribe. The Ndebele people, sometimes known as the Matabele, are also well known for their artistic talent—especially with regard to their painted houses and colorful beadwork.

The principal ethnic majority in Botswana is the Tswana (hence the country's name), who account for 76 percent of the 1.6 million people in the country. The people of Tswana origin and also the citizens of the country are called Batswana or Motswana. Although many speak English, the official language of Botswana is Setswana. Since its independence from Britain in 1966, Botswana has maintained the highest level of economic growth in Africa, and one of the highest in the world. The country is the sec-

ond largest producer of diamonds in the world, and is number one in production of gemstones.

The Setswana belief is that people have *botho*, which means the good qualities of a human being. These include kindness, good manners, compassion, humility, respect for others (especially the elderly), and living up to one's responsibilities. Although more commonly referred to in Botswana, the qualities are evident throughout the peoples of both Botswana and Zimbabwe.

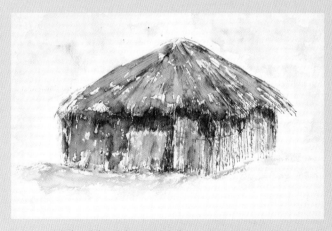

Mud and thatch hut in Zimbabwe, ink and watercolor
on cold press paper, 2006

day. These are dangerous periods for the cubs. Lions, baboons, and hyenas may come looking for an easy meal, so a mother often moves her cubs to new hiding places to confuse the enemies.

During the cubs' first year, their mother gives them hunting lessons. At first she shows them how to catch small animals such as hares and birds; then the cubs try for bigger prey. Young cubs practice hunting by sneaking up on rocks and attacking bushes. They also practice with their mother, who sometimes hides so the cubs can look for her. Some cubs can kill a small antelope before they are one year old. Finally, when they're about 18 months old, the cubs venture out on their own.

LEOPARD (*Panthera pardus*)

MARKINGS: Light tan or fawn colored with black rosettes on upper side (two to four black spots around body-colored center); at end of long tail spots fuse into several rings, with a black tip.

SIZE: Males can weigh up to 200 pounds; females are about two-thirds the size of the males. From tip of the nose to the tip of the tail, a leopard can reach lengths of up to 9.5 feet and stand about 2.5 feet tall.

BEHAVIOR: Where hunted, leopards are very secretive and nocturnal, and are masters at camouflage; at times they can only be spotted by the black tip of the tail above the high grasses or dangling down from a tree limb. They are solitary animals by nature, males only associating with females for mating and staying with her for only a few days. Leopards have a rough, sawing cough repeated up to a dozen times as territorial claim or as a means of contacting another leopard. Females greet their young with soft, quickly repeated calls.

GESTATION: Just over three months, with cubs born in rock crevices or holes, hollow trees, and reedy nests or thickets. A litter usually consists of two to three cubs, sometimes up to six. Cubs' eyes will open at about one week; they become independent at the age of about two years.

LIFE SPAN: Up to 21 years in captivity; about 15 in the wild.

PREDATORS AND PREY: Occasionally preyed upon by lions, hunting dogs, spotted hyenas, and crocodiles. Young leopards may be endangered by hyenas, jackals, and similar-sized predators. Any medium-sized mammals are prey for leopards, including antelopes, lion cubs, young apes, domestic stock, birds up to the size of a stork, snakes, tortoises, fish, and insects. Domestic dogs and all monkeys are favorite prey. Leopards are the most successful hunters of the cat family.

DEFENSE: A leopard's ability to remain camouflaged and its silent maneuvering are its best defenses, as well as its strength: for its size, it is the strongest feline in the world apart from the jaguar. When hunting, leopards move silently through the vegetation to attack their prey at very close quarters. They then drag the catch up a tree, away from scavengers.

CONSERVATION: The leopard is doing surprisingly well for a large predator. It is estimated that there are as many as 500,000 leopards worldwide. But, like many other big cats, leopards are increasingly under threat of habitat loss and increased hunting pressure. Because of their stealthy habits and camouflage, they can go undetected even in close proximity to human settlements. Despite the leopard's abilities, it is no match for habitat destruction and poachers.

Kudu, ink and watercolor on rice paper, 2005

EXPLORING LINYANTI

We quietly left the reunited mother and cub and headed to our camp. Savuti Camp is small and intimate, with a rustic feel. Each of the five large walk-in, tented rooms, complete with ceiling fans, is raised off the ground on a polished wooden deck that provides wonderful views over the vast grasslands. A thatched dining area overlooks the water hole in front of the camp. After a late dinner, we spent the rest of the evening around the fire, reflecting on this new world unfolding before us and speculating about what surprises the days ahead would bring.

Savuti is one of only four camps in the 275,000-acre Linyanti Wildlife Reserve, a vast, private sanctuary for an abundance of African wildlife on the western boundary of Botswana's famous Chobe National Park. Game concentrations here are high; the area is particularly known for its dense elephant population. During the dry season, droves of elephants bully each other around half-empty water holes while thirsty wart hogs, kudu, and impala wait in the shade. Hundreds of visiting birds—swelling the region's 300 resident species—come during the rains, as do thousands of migrating zebras, providing a feast for lions and hyenas.

IMPALAS AND ANTELOPES

While my intent on this safari was to see the "Big Five," I was beginning to discover the lesser-known but equally fascinating species that inhabit this part of Africa. One of the most ubiquitous is the graceful impala (*Aepyceros melampus*), a medium-sized, deerlike creature with a silky golden coat. Only the males have horns, which are lyre-shaped and permanent.

Impalas are very sociable, usually seen in smaller groups (known as harems) of six to 24 animals consisting of mostly females with young (called "lambs") and one old male. At times herds can number up to 50 or, in rare instances, over 200. No males of more than six months old are tolerated in a harem; the young males and those without a territory usually form separate "bachelor groups," with older animals in charge. The rams fight for control during the rut in March and April, and then attempt to retain groups of females on their terrain. These quick and agile creatures can reach speeds of up to 40 miles per hour, and, in flight, make numerous leaps—possibly for orientation—up to nine feet high and 30 feet long, as well as a series of comical-looking vertical jumps known as "pronking."

Impala, charcoal on cold press paper, 2005

GREATER KUDU (*Tragelaphus strepsiceros*)

MARKINGS: Has a reddish-brown coat with white transverse stripes on its body. Long, corkscrewlike horns on the males. Has a long hair crest from nape to root of tail. Males also have a long lower neck mane from the throat to the base of the neck. Large, tufted ears are extremely sensitive to sound.

SIZE: Males weigh up to 700 pounds and stand about five feet high; females are considerably smaller at a maximum of 475 pounds.

BEHAVIOR: Kudus rest in thick bush by day and come out to browse in the late afternoon. The animals live in small troops of several females with their young, to which at times one or two old males attach themselves. Troops generally have six to 12 members; rarely 20 to 30. Kudus prefer stony ground or bushy areas on hills and mountains, and tend to stay in one territory. The kudu is a renowned jumper, leaping over obstacles as high as eight feet.

GESTATION: About seven months, with one active young that lies close to its mother for about two weeks. The calf has a "maaa" contact call and a long "oooo" alarm.

LIFE SPAN: Only about seven to eight years in the wild, but up to 23 years recorded in captivity.

PREDATORS: Kudu are preyed upon by leopards, hunting dogs, cheetahs, and lion, who all tend to go after the young and the females, rather than the older males. Young calves are also threatened by servals, caracals, eagles, and pythons.

DEFENSE: Escape from enemies generally only by flight; an old male seldom defends itself even if cornered. The male kudu's horns are formidable, however, and they will sometimes use them to fight to the death over territory. Sometimes two males' spiral horns will become so interlocked in fighting that they can't separate, when both animals die.

CONSERVATION: Although the greater kudu is considered a low-risk, conservation-dependent species, it is hunted for its horns. It is also hunted for its meat, and has a reputation in some areas as a pest because of occasional crop damage. Along with these factors, kudu, largely woodland animals, suffer from habitat destruction.

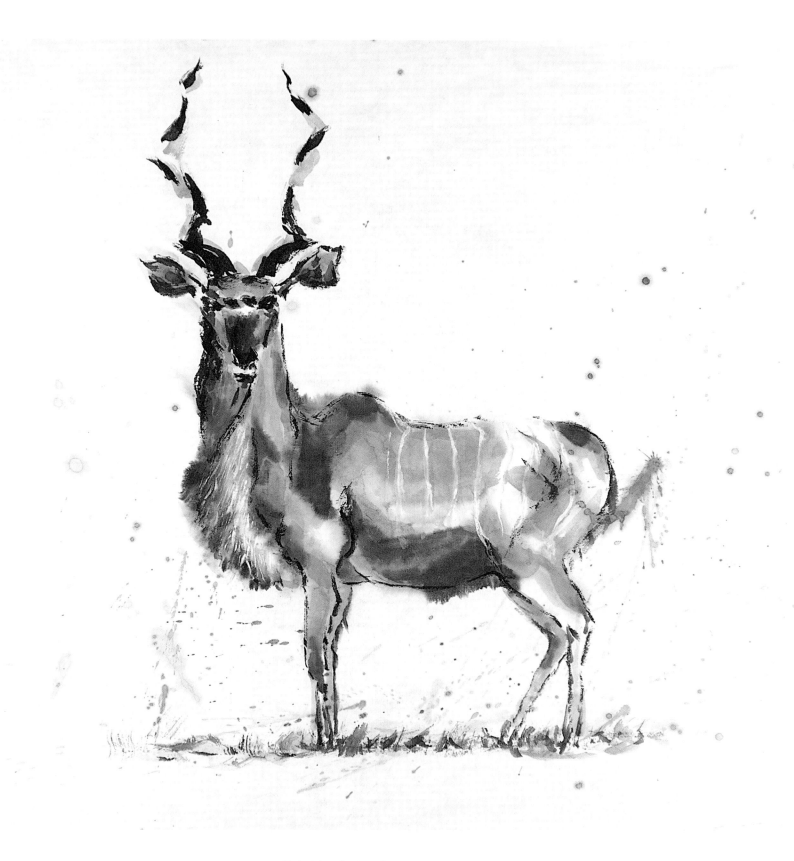

Kudu, ink and watercolor on rice paper, 2005

Arguably Africa's most impressive and beautiful antelope is the greater kudu (*Tragelaphus strepsiceros*). Tall and stately, this elegant animal has a reddish-brown coat with white transverse stripes on its body. From the age of two the males grow long, corkscrewlike horns that they use to defend their territory, sometimes fighting to the death. The kudu's favorite habitat is the thick acacia bush-clad banks of seasonably dried-out riverbeds, which provide vital thickets for resting during the day. These renowned jumpers, can easily clear six-foot fences, and also like stony ground and bush on hills, mountains, and plains.

This part of Africa is also one of the last domains of the disappearing roan and sable antelopes. The roan (*Hippotragus equinus*) is about the size of a horse, with a reddish-gray coat and distinctive black, white, and brown facial pattern; both sexes sport steeply rising horns that curve backward in a series of rings. Rival males fight on their knees with violent backward sweeps of the horns. The more rare sable (*Hippotragus niger*) is similar in appearance to the roan, but somewhat smaller, with a dark chestnut brown, almost black, coat and even longer horns.

ZEBRA AND WILDEBEEST

Probably two of the most recognizable animals of the plains are the zebra and the wildebeest, who often migrate and generally share the rare habitat, largely because of the symbiotic relationship between the two species: the wildebeest prefers the short grass, the zebra the long grass; and the wildebeest's acute senses of hearing and smell complement the zebra's excellent eyesight.

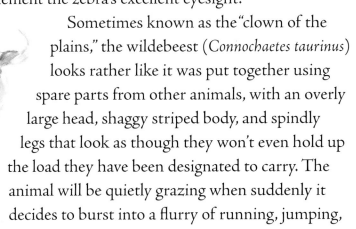

Sometimes known as the "clown of the plains," the wildebeest (*Connochaetes taurinus*) looks rather like it was put together using spare parts from other animals, with an overly large head, shaggy striped body, and spindly legs that look as though they won't even hold up the load they have been designated to carry. The animal will be quietly grazing when suddenly it decides to burst into a flurry of running, jumping,

Wildebeest, ink and watercolor on rice paper, 2005

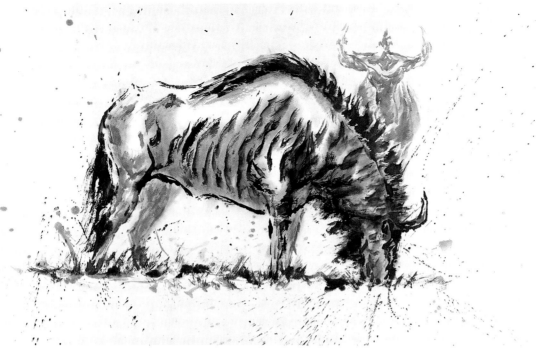

Wildebeest, ink and watercolor on rice paper, 2005

WILDEBEEST (*Connochaetes taurinus*)

MARKINGS: Base of coat comes in varying shades of grey, with dark vertical bands marking the neck and fore-quarters, which, from a distance, may appear to be wrinkles in the skin. Both sexes possess horns, which extend outward to the side and then curve upward and slightly inward.

SIZE: Wildebeest grow to nearly five feet at the shoulder and weigh between 330 and 550 pounds.

BEHAVIOR: Wildebeest migrate, or travel, more than 800 miles a year. Always on the move, they search for green grass and water. The migration of the Serengeti wildebeest is one of the best-known and most-studied migrations in Africa. Almost a million wildebeest make the seasonal move from their wet-season range on the open plains to their dry-season refuge in the woodlands, a round trip of about 250 miles. The strong bulls in every wildebeest group defend territories; young males and bulls without territories form bachelor herds. Bachelors are forced to live on the fringes of the herd. If a herd of bachelors drifts into a bull's territory, the bull quickly chases the group out. Wildebeest exhibit early-morning and late-afternoon grazing peaks. They are very water dependent, need-ing to drink almost daily. This limits them to pastures that are within commuting distance to water sources, generally five to ten miles.

GESTATION: About eight months, with one active young. Large herds of 20 or more calve at the same time. Cows calve in summer, on the plains. The calves can walk within minutes, and after a few days can keep up with the rest of the herd during the wildebeest's grueling migration. In smaller herds, about 50 percent of the calves are lost to predation.

LIFE SPAN: Wildebeest can live for about 18 years in the wild and 20 in captivity.

PREDATORS: Lion, leopard, cheetah, spotted hyena, wild dog, crocodile, and, if calves, black-backed jackal.

DEFENSE: Cows will put up a spirited defense of their babies, but the odds are stacked against them, espe-cially if a pack of dogs or a spotted hyena clan attacks. Mother will not attempt to fight off a lioness; flight is the only option.

CONSERVATION: Although the wild population of common wildebeest is close to 1,250,000, their long-term future is by no means assured. The biggest threat to wilde-beest populations is continued loss of habitat due to the expansion of human settlements.

kicking, and snorting, its large head shaking wildly as it performs this comical dance. Although this odd behavior is attributed by some to a batfly laying its eggs in the wildebeest's nasal cavity and the larva working its way up into the animal's brain, what is probably closer to the truth is that the crazy capering serves as a threat to intruding neighbors.

During the dry season, after the pastures are grazed off, wildebeest harems will converge into larger herds to seek out new grazing grounds. This is most impressive in the famed Serengeti-Mara farther north at the border of Tanzania and Kenya, where enormous herds of up to 400,000 animals wander after the rains.

Zebra, ink and watercolor on rice paper, 2005

COMMON (BURCHELL'S) ZEBRA *(Hippotigris quagga)*

MARKINGS: Body covered in black stripes on a cream to yellowish base, with a great individual variation in pattern; no two are alike. Erect black mane from forehead to withers.

SIZE: Males weigh up to 700 pounds; females slightly smaller, up to 550 pounds. Zebras stand about five feet high and a maximum of eight feet long.

BEHAVIOR: Zebras spend the better part of each day grazing, moving into an area and eating the long grasses, paving the way for the wildebeest and gazelle, who prefer to eat the short grasses. Zebras live in closely bonded family groups consisting of one to six mares with foals, and one old stallion who has the highest rank, followed by other males in order of age. One animal always remains on guard while the others sleep. If a herd member is sick or injured, the herd will adjust their pace to accommodate the hurt animal. The zebra's distinctive warning or contact call is a double "ee-aa." Families joining in large herds recognize each other by stripe pattern, voice, and scent.

GESTATION: About one year, with one active young (twins rarely). For the first few days after birth the mare drives other animals from the foal, which has an innate following reaction. The foal learns to recognize its mother after only three to four days.

LIFE SPAN: Only about 20 years in the wild, compared with 40 years in captivity.

PREDATORS: Mainly lions; in some areas also spotted hyenas and hunting dogs. Foals are also in danger from leopards and cheetahs.

DEFENSE: When threatened the family closes up and eventually takes flight, with a lead mare at the front and the old stallion as rear guard. Zebra will attack single hyenas; they fight lions and hyena packs with ferocious kicking, which sometimes disables the attacking predator.

CONSERVATION: While the related Grevy's zebra *(Hippotigris grevyi)* and the Mountain zebra *(Hippotigris zebra)* are considered endangered or threatened, the Burchell's zebra numbers remain high, although their habitat and grazing grounds are diminishing rapidly.

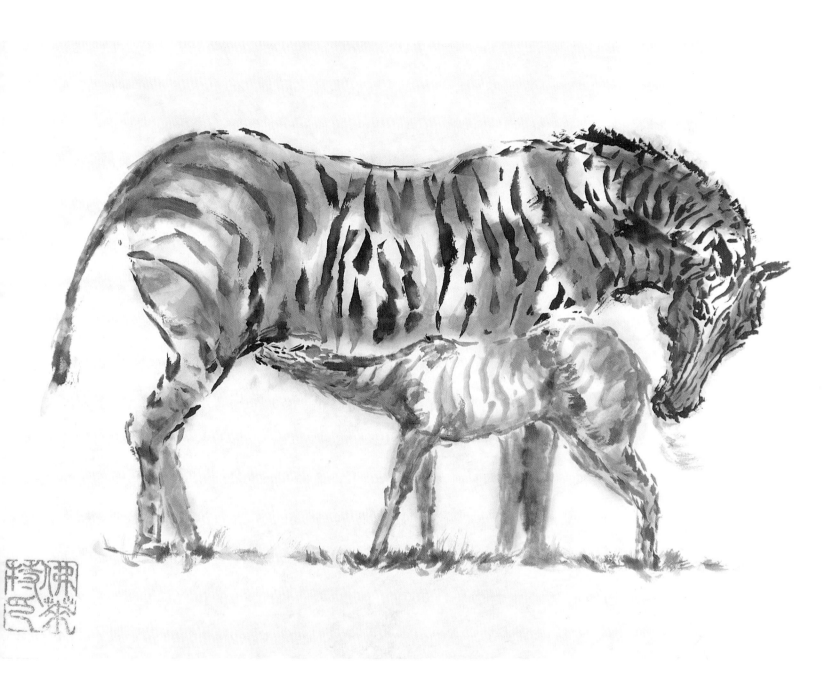

Zebra mother with foal, ink and watercolor on rice paper, 2005

Warty, the one-eared wart hog, ink and watercolor on rice paper, 2005

There are several species of zebra in southern Africa, the most common being the Burchell's zebra (*Hippotigris quagga*). These animals, which appear docile, can break the back of a hyena with a single kick. You can often hear their loud and distinctive warning call—a double "ee-aa" that sounds like a cross between a dog barking and a donkey braying—before you even glimpse the animal. Families joining in large herds recognize each other by stripe pattern, voice, and scent. Studies have indicated that stripes may appear on zebra embryos at three to five weeks of gestation; each pattern is unique.

THE WART HOG

With a face only a mother could love, the wart hog (*Phacochoerus aethiopicus*) is seen virtually everywhere, with widespread distribution throughout central and southern Africa. Sometimes known as the "naked swine of the savanna" because of its virtually hairless body, which sprouts only a few coarse tufts of hair, its name is derived from the not-so-attractive warts found just below its eyes; on males, the warts can be up to six inches long. Males also have two smaller warts just above the nostrils. The wart hog has a large flat face with prominent tusks; the upper tusks can be up to two feet in length. Those tusks come in handy. Though it would rather run from predators than fight, a wart hog can be very fierce if necessary, and will ferociously defend its family.

The wart hog sleeps in a self-excavated burrow, which is essential to its safety. When being chased, the animal will often head for its burrow and, just before entering, spin around and back in, so that its "business end" with sharp tusks is ready and waiting for any snooping predators, such as cheetahs, wild dogs, or spotted hyenas.

Wart hogs are fairly habitual and territorial creatures.

Warty, the one-eared wart hog, ink and watercolor on rice paper, 2005

Our guide visits one, affectionately named "Warty, the One-Eared Wart Hog," every day; he has checked on Warty and her family for the past several years. She is missing her right ear as the result of a leopard attack. The leopard had chased Warty and clamped down on her ear with its powerful jaws. While the leopard was trying to get a better grip, Warty screamed wildly, alerting every animal within miles that something was going on. Of course the opportunistic hyenas heard, for they often steal prey from cheetahs and leopards. When hyenas come upon a leopard with a kill, the leopard will abandon its kill, because a lone leopard or cheetah cannot defend itself against a pack. In this case, as soon as the hyenas appeared on the scene, the leopard retreated, with only Warty's right ear as a prize. Sadly, later that year the leopard returned to the burrow and pounced on Warty's piglets.

Now, a year later, Warty had found a mate, and we watched them every morning foraging for food as we left camp. Wart hogs drop to their front knees and use their

WART HOG (*Phacochoerus aethiopicus*)

MARKINGS: A virtually hairless grey body sprouting only a few coarse tufts of hair. Warts just below its eyes; on males can be up to six inches long. Males also have two smaller warts just above the nostrils. The wart hog has a large flat face with prominent tusks; the upper tusks can be up to two feet in length.

SIZE: Males can weigh up to 300 pounds; females half that. The adult animal stands about three feet high and is around five feet long.

BEHAVIOR: Very piglike, snorting and snuffling along the ground, eating short grass, fallen fruit, green bark, and digging in the earth for tubers and roots. Sometimes a wart hog will also go after small mammals and carrion. Live in family groups of parents and two to four young, sometimes also with adopted orphans. It is thought that wart hogs mate for life. The wart hogs make their homes in abandoned aardvark holes, self-excavated termite hills, holes among rocks, or cavities in the ground.

GESTATION: About six months, with a usual litter size of two to four young, although up to eight. The young leave the hole after a week and start to eat grass.

LIFE SPAN: Up to 18 years recorded in the wild.

PREDATORS: Mainly lions and leopards, although cheetahs sometimes take young or isolated animals.

DEFENSE: The male wart hog protects its family with its lower tusks, which the mother also uses to protect her young. When being chased, the animal will back into its burrow, so that its sharp tusks face out, ready to do some damage.

INTERESTING FACT: Wart hogs allow birds, such as the yellow hornbills, to eat parasites that live on their bodies. This symbiotic relationship allows the birds to have a constant food source and the hogs to rid themselves of pests.

CONSERVATION: Because of its adaptability to many types of terrain, wart hog populations remain stable throughout Africa.

snouts as shovels to dig in the ground. This, along with a keen sense of smell, enables them to find their favorite foods, which usually consist of roots, bulbs, fungi, fruit, and eggs—although they will also eat invertebrates, birds, small mammals, and carrion. Wart hogs can live for up to 18 years and have litters of two to seven piglets. It is comical to watch a wart hog family on the run; their tails stick straight up in the air like antennae—which some believe gave rise to the phrase "hightail it."

Giraffe drinking, ink and watercolor on rice paper, 2005

TWO GIANTS

Towering over all of these creatures is the gentle giraffe (*Giraffa camelopardalis*), the tallest land animal, reaching a height of up to 18 feet and weighing up to 2,000 pounds. The species name *camelopardalis* (camelopard) is derived from its early Roman name, which described it as having characteristics of both a camel and a leopard (and perhaps being a hybrid of the two). There are nine subspecies on the continent of Africa; the one prevalent in Botswana is the South African giraffe, which has round or blotched spots, some with star-like extensions on a light tan background.

The giraffe's famous neck, while allowing the animal to browse the treetops, gives it a bit of a problem when it comes to drinking, which it achieves by spreading its forelegs wide and bending down. A giraffe's heart, which can weigh up to 24 pounds, has to generate about double the normal blood pressure for a large mammal in order to maintain blood flow to the brain against gravity. In the upper neck, a complex pressure-regulation system prevents excess blood flow to the brain when the giraffe lowers its head to drink.

Giraffe and baby, ink and watercolor on rice paper, 2005

Trotting giraffe, ink and watercolor on rice paper, 2005

GIRAFFE *(Giraffa camelopardalis)*

MARKINGS: The Southern African giraffe has round or blotched spots, some with starlike extensions, on a light tan background.

SIZE: The tallest land animal, giraffes can reach heights of up to 18 feet and weigh up to 2,000 pounds.

BEHAVIOR: Giraffes spend mornings and afternoons grazing, mainly on the foliage of trees and bushes (preferably acacias). At night, the animals will rest, either standing up or lying down. They travel in troops, usually two to six animals, with the mother at the center and several families making a troop. Old males may wander and eventually form new associations. Rival males sometimes fight violently; they stare at each other, then suddenly throw their necks violently, usually inflicting powerful blows with the small knobbed horns on top of their heads. A strong blow can even break a rival's neck. Although giraffes are largely silent, they sometimes bleat in excitement, rising to a screaming bellow.

GESTATION: Between 14 and 15 months, after which a single calf is born. The mother gives birth standing up, and the embryonic sack bursts when the baby falls the six feet or so to the ground. Within a few hours, the six-foot-tall calf can run around, but for the first two weeks it spends most of its time lying down, guarded by the mother. Only 25 to 50 percent of giraffe calves reach adulthood.

LIFE SPAN: Between 20 and 25 years in the wild; up to 28 years in captivity.

PREDATORS: Lions are a threat to young giraffes.

DEFENSE: The giraffe's best defense is its powerful kicks.

INTERESTING FACT: The giraffe's heart is one of the most powerful among animals, because it takes about twice the normal pressure to pump blood up the giraffe's long neck to the brain. Also fascinating is the fact that blood does not pool in the legs, and therefore, a giraffe does not bleed profusely if cut on the leg. The giraffe's long neck not only aids the animal in feeding, but serves as a weapon, used by males for combat and competition.

CONSERVATION: With an estimated population of 141,000 in Africa, giraffes are at lower risk of endangerment. Uncontrolled poaching is their main threat, responsible for most of their range restriction in North and West Africa.

Giraffe, oil on copper, 30 x 50 in., 2005

Conversely, the blood vessels in the lower legs are under great pressure, because of the weight of fluid pressing down on them. In other animals such pressure would force the blood out through the capillary walls; giraffes, however, have a very tight sheath of thick skin over their lower limbs that maintains high extravascular pressure.

We were thrilled one afternoon to see a baby giraffe, which our guide estimated to be about two weeks old. Giraffe gestation lasts between 14 and 15 months, after which a single calf is born. The mother gives birth standing up, and the embryonic sac actually bursts when the baby falls the six feet or so to the ground. For a newborn to survive this fall is a miracle in itself. After the birth, the mother gently extends her long, prehensile tongue and begins to clean her calf. Eventually the wobbly neck gains strength and supports a very startled-looking face as it rises above the bush, looking like some sort of cute alien creature with huge eyes and ears.

Within a few hours of birth, the six-foot-tall calf can run around, but for the first two weeks it spends most of its time lying down, guarded by the mother. While adult giraffes are too large to be attacked by most predators, the young fall prey to lions, leopards, hyenas, and wild dogs. Although their characteristic spotted pattern provides a certain degree of camouflage, only 25 to 50 percent of giraffe calves reach adulthood; those that do have a life expectancy between 20 and 25 years.

ELEPHANTS IN LINYANTI RESERVE

Amazingly, with its unique nasal appendage, a big elephant can feed anywhere from the ground up to 20 feet higher than a giraffe can reach. Some of the largest herds of elephants in Africa congregate in the Linyanti Reserve, and we were fortunate to see quite a few of them. One day we sat in our Land Rover at a watering hole in the Savuti Channel and watched a herd of at least two dozen charge down a hill with their youngsters in tow, throwing dust all about and plunging themselves into the mud. The dust was so thick, at times we could see only the out-lines of the elephants on the outer edge. Our own nostrils and eyes were filled with the fine dust kicked up by these great beasts.

Baby elephant kneeling to drink, ink and watercolor on rice paper, 2005

All elephants treasure a mud bath. It keeps them cool, reduces ticks, and is pretty much just darn good fun. Bathing elephants roll and wallow in the shallows, often submerging completely in the water. At smaller watering holes, elephants just take a quick shower, sucking up water in their trunks and spraying themselves. To complete the beauty treatment, they again use that wonderful trunk to coat themselves with mud or dust.

Elephants have just one basic gait: an ambling walk of up to five miles per hour. Longer, quicker strides may boost that speed up to eight miles per hour, and a charging elephant can hit 25 miles per hour, much faster than a human can run. When elephants don't want to go anywhere, there they stay—as evidenced one evening as we hurried along in the dark and nearly ran into an "elephant wall." Looking very much like the defensive line of the Chicago Bears, these boys weren't going anywhere fast. The bachelor herd was calmly grazing right across our only route back to camp, and we were barricaded. We sat there for about an hour, watching them, waiting. Finally, they decided to let us through. It was an exercise in patience and a lesson on "Africa time," where nature, not the clock, runs your life.

FOR THE BIRDS

I'm not a big "bird person." But, with about 577 bird species, Botswana offers some brilliant birding opportunities—and I've got to admit, some of them were interesting and artistically inspiring, not to mention beautiful. The wonderful grasslands alone host many species, such as the colorful carmine bee-eaters, korhaan, sand grouse, and quail. Migrant Abdim's storks and white storks congregate in large numbers during the summer months. You can also see coursers, ostrich, the large secretary bird, and the tawny and bateleur eagles. The persistent efforts of our guides to point out the wide variety of bird life did pay off with me in the end, and there were some species that particularly caught my eye.

The kori bustard (*Ardeotis kori*) is a fairly common resident and it is one of the heaviest flying birds, weighing up to 40 pounds. It is identified by its huge size and crested head. Kori bustards are seen single, in pairs, or in groups in woodland and on

SOME UNIQUE AFRICAN TREES

One of the most recognizable trees of the African savanna is the umbrella thorn tree, or umbrella acacia (*Acacia tortillas*). This hardy tree can survive in areas with rainfall as low as one-and-a-half inches per year, withstanding temperatures of 122 degrees Fahrenheit during the day and below freezing at night. The umbrella thorn grows up to 66 feet high and has a spreading, flat-topped crown that gives it its name.

Fruit from the African sausage tree, ink and watercolor on cold press paper, 2006

The umbrella thorn tree has developed an ingenious root system that allows it to survive in Africa's hot, dry conditions. Its deep taproot can reach 115 feet under the ground, helping it get water during the dry spells. A second set of roots spreads out just under the earth's surface to about twice the area of the crown and enables the tree to utilize every little bit of moisture that seeps into the soil. Even the little leaves of the umbrella thorn help; their small size prevents water loss. The tree's umbrella-shaped top enables it to capture large amounts of sunlight with the small-estpossible leaves. While its thorns are used to dissuade the savanna animals from eating the leaves, flowers, and seedpods (the only animal immune to the thorns is the giraffe), the acacia provides much-needed shade for the area wildlife. The trunk of the tree makes very good charcoal and firewood, and acacia honey is a prized by-product in some regions. The stem of the tree is used to treat asthma and diarrhea, while the bark is used as a disinfectant and the pods are used to make porridge.

We also took note of the interesting-looking sausage tree (*Kigelia africana*), which has a thick trunk with gray bark and an attractive rounded profile. Its deep red flowers give way to pendulous fruits that sometimes reach lengths of up to three feet. In the early stages of development, the fruits are decidedly phallic-looking; later they resemble large sausages hanging by string at a German butcher shop. As with many other African trees, not much of the sausage tree goes to waste. The bark is made into a tea for the treatment of hypertension; a salve made from the powder of the fruit is used on ulcers and sores.

Umbrella thorn tree, ink and watercolor on rice paper, 2006

*The highest wisdom has but one science—
the science of the whole—the science explaining
the whole creation and man's place in it.*

—LEO TOLSTOY, AUTHOR

the grassy plains. The large bird walks slowly, with measured strides, and flies reluctantly. Its courtship ritual is really something to see: the male inflates his throat like a balloon, raises his crest and draws back his head, lets his wings droop, and deflects his tail upward and forward to the neck. He then emits a low-pitched booming noise as he snaps his bill open and shut. Females presumably are attracted to the male with the most superior display.

Although Botswana is a stronghold for the kori bustard, it is threatened by habitat loss from overgrazing and poaching. Many of the birds are poached for local consumption; in some areas the bird is so revered that only tribal elders are allowed to eat bustard meat. There is also evidence of illegal cross-border trafficking in live bustards. Up to ten at a time are smuggled into South Africa, where they are sold as a delicacy to wealthy individuals or exported outside Africa.

One of Africa's prettiest and most accessible birds is the lilac-breasted roller (*Coracias caudate*), a very colorful, heavy-billed bird with brilliant blue wing feathers and a harsh, croaking voice. Rollers spend much of the day hunting from a convenient perch, flying down to seize large insects, small reptiles, and other small prey on the ground. Lilac-breasted rollers breed in holes in trees and have active display flights that involve aerial maneuvers with much harsh calling. They are found in a variety of woodland types and are usually seen hawking for insects from a favored position in a tall tree or similar vantage point.

Another common bird that caught my eye was the Egyptian goose (*Alopochen aegyptiacus*), which frequents rivers, marshes, and lakes and has a wide range of nesting sites. This bird was considered sacred by the ancient Egyptians. The geese, which

Lilac-breasted rollers, dye on silk, 2005

are known to remain together for long and lasting periods—some mate for life—may select cavities and holes in trees, as well as the abandoned nests of other birds and ledges on cliffs and banks. Attractively marked, particularly in flight, when their distinctive white wing-coverts are revealed, Egyptian geese draw attention to themselves with noisy displays and fierce territorial fighting both afloat and ashore. Rivals stand or swim, breast to breast, continually attempting to seize each other's backs near the base of the neck while beating with wings and even striking with feet. Following egg laying, the birds almost disappear until the time comes to escort flotillas of goslings to the water.

Probably the ugliest bird I have ever seen is the marabou stork (*Leptoptilos crumeniferus*). It can be huge—up to five feet tall, with a wingspan of up to 8.5 feet. The heavy-bodied stork has black plumage above and white below, with no feathers at all on its pink and pimply head and neck. The bird also has a long, reddish pouch hanging from its neck, which is used in courtship rituals. The featherless, 18-inch

inflatable pink sac is particularly conspicuous during the breeding season. It connects directly to the left nostril and acts as a resonator, allowing the bird to produce a guttural croaking. The marabou will clack its conical beak if it feels threatened. Known as the undertaker of the wild, the marabou is a scavenger, eating anything from termites, flamingoes, and small birds and mammals to human refuse and dead elephants. They also feed on carcasses alongside vultures and hyenas.

THE PLAINS BY NIGHT

There is no experience quite like a night game drive; it offers the element of the unknown, of surprises lurking around every corner and behind every tree. You're driving through the dark into what seems like miles of nothingness, when suddenly your guide aims his powerful red light into the bush and it comes alive with the lights of a thousand eyes—hyena eyes, impala eyes, lion eyes. All of these eyes light up on the horizon in spectacular display . Not only does a night game drive allow you to see the more common animals' nighttime activities, it provides a glimpse into the world of Africa's rarely observed nocturnal wildlife.

AFRICAN CATS

Just like domestic cats, African cats sleep a lot during the day and are more active by night. The African civet (*Viverra civetta*) is a fairly large black-and-white cat—about the size of a medium-sized dog—with a broad head, small eyes, and a body that distinctly slopes from back to front due to hind legs that are longer than the forelegs. It has a long, bushy tail with black rings; its body is marked with an unusual mix of spots and stripes. When the sun goes down, the civet goes on the prowl for delicacies such as antelope calves, birds, eggs, domestic poultry, carrion, frogs and toads, reptiles, and even house cats. It will round off its meal with fruit, berries, or vegetation.

Another cat we saw during our night game drives was the beautiful serval (*Leptailurus serval*). This long-legged creature

Caracal and track, charcoal on cold press paper, 2005

88

is light colored with large black spots arranged in neat rows on its lean body; its tail is fairly short and marked with black rings. Although technically not nocturnal, it is active at dusk or on moonlit nights, using its large ears to seek out prey; a favorite meal is rodents, which the cat will stalk and pounce upon. The serval also takes birds up to guinea fowl size, grabbing flying birds out of the air with a high leap.

The genet cat (*Genetta genetta*) is definitely a creature of the night, although it's really not a cat at all and is more closely related to a mongoose. Long and lean, with a pointed snout, it has a black-spotted body with a long, ringed tail. It hunts for small animals up to the size of a hare, small birds, eggs, lizards, snakes, frogs, fish, insects, spiders, scorpions, and millipedes. The genet tames easily; there is evidence it was kept in homes in ancient Egypt as an efficient mouse and rat killer.

Serval and track, charcoal on cold press paper, 2005

OTHER CREATURES OF THE NIGHT

The "cute" award for nocturnal animals has to go to the bat-eared fox (*Otocyon megalotis*), a light-colored fox with long legs, big eyes, and huge dishlike ears. These family-oriented foxes mate for life and have litters of three to four pups. Almost exclusively insectivorous—eating mainly termites and grasshoppers—the fox will sometimes also go after rodents and other small mammals.

One of the most fascinating creatures we saw at night was the African crested porcupine (*Hystrix africae australis*). Much larger than you might expect, this porcupine grows up to three feet long and can weigh up to 60 pounds. Dark brown, with a white neck and a long white crest or mane of wiry bristle hairs protruding from the back of its neck, the porcupine's most distinguishing feature is, of course, the many black-and-white ringed quills that cover its

African crested porcupine, charcoal on cold press paper, 2005

Porcupine track, charcoal on cold press paper, 2005

back, flanks, and the upper side of its tail. The end of the tail has hollow quills open at the end, known as the "rattle-quills." We could hear these rattle when the animals ran.

Occasional predators of the porcupine include leopards, lions, and hyenas, although the porcupine's excellent defense is generally a deterrent. If threatened, the animal stamps its hind feet and shakes its rattle-quills. When in danger, the porcupine erects its quills and jumps backward to drive the points into the opponent. If pursued, the animal may stop suddenly, causing the predator to run into its quills. Contrary to popular belief, the porcupine does not shoot its quills, but instead they fall out easily when they come in contact with something. A porcupine's quill can actually kill a predator, though not from any poison; if a quill gets in the predator's muzzle, mouth, or paw and the wound becomes infected, the animal could eventually die.

What is the answer to the age-old question of how do porcupines mate? Very carefully, certainly. The female erects her tail and lays her quills flat; the act is brief. Two litters per year are possible, and there are usually two active young in a litter, which are born with their eyes open and short, soft quills.

Returning to our tents late one night, I had newfound respect for the unseen dramas being played out beyond the boundaries of our camp. I felt I had been privileged to visit a secret part of Africa, one not normally viewed by human eyes. It was a humbling experience.

THE MEAT EATERS

Carnivores are plentiful here, and they come in all sizes. One of the smallest is the southern dwarf mongoose (*Helogale parvula*), a sharp-faced, small-eared, short-legged creature with a long tail that makes its home in termite mounds, burrows, fallen

Southern dwarf mongoose and track, charcoal on cold press paper, 2005

Spotted hyenas, ink and watercolor on rice paper, 2005

trees, stone heaps, and rock piles. Its fearless curiosity often puts it in danger from larger predators and birds of prey. Like other members of the mongoose family, the dwarf mongoose kills and eats snakes, as well as insects, lizards, small birds and mammals, and eggs, fruit, and berries. Like prairie dogs, these cute little creatures often pop out of their burrows, scouting the landscape intently.

Spotted hyenas are as plentiful in Botswana as they are in Zimbabwe, but here in the Savuti Channel they are a little more brazen, often banding together and rushing elephants at a water hole, howling and screaming as they attack. This is a tricky tactic designed to cause the elephants to stampede and scatter in a wild panic. In the mêlée, baby elephants are often inadvertently left behind or trip over debris, becoming ready

prey for the hungry hyenas—if the hyenas can attack them before the elephants' mother notices and returns with a vengeance. At one such water hole, we witnessed a baby elephant on its knees, drinking with its mouth instead of taking in water through its trunk and squirting it into its mouth, as is normally the practice. It had been a victim of one of these hyena raids; before its mother could return to rescue it, the hyenas had torn off the tip of its trunk, in effect eliminating its ability to use the trunk as a normal elephant would. Unfortunately, the brutal attack will probably shorten its lifespan, as the elephant's trunk is an all-important tool for seizing vegetation to eat, as well as for breathing, smelling, drinking, and fighting.

Black-backed jackal, charcoal on cold press paper, 2005

We saw two different types of jackal in the Savuti Channel. Looking very similar to the coyotes of the American Southwest, they share the same characteristic of mating for life. The black-backed or silver-backed jackal (*Canis mesomelas*) is more commonly seen than the side-striped jackal (*Canis adustus*), which is rare and prefers heavily wooded or cultivated areas. They both feed on insects, small mammals, fruit, and vegetation, as well as carrion. Both types of jackal are good hunters, often joining up with other jackals to bring down larger prey, but they are also notorious scavengers who enjoy feasting on the remains of a larger predator's hunt. Jackals often

Black-backed jackal with carcass and track, charcoal on cold press paper, 2005

prefer to trot around looking for a meal at night, particularly if in a populated area. They also have an interesting relationship with hyenas, calling in the stronger-jawed animals to help them tear apart the flesh from a carcass. The hyenas rip it apart and the jackals pick up the scraps; the hyenas crunch up even the bones when all else is gone. Nothing is wasted. What was once a large and powerful Cape buffalo will end up as a mere skull with horns, lying on the savanna grass.

THE SAVUTI LIONS

Of the larger predators, the lion and leopard are both relatively plentiful in the Savuti area, the latter particularly favoring rocky outcrops for sunning and sleeping. The lions here are rather famous for a number of reasons, one being that unlike their East African cousins, the cats of Savuti do almost all of their stalking and killing at night, giving them the name "Lions of Darkness." The moniker also refers to a strong male coalition here who exercise considerable influence over their range, the subject of a well-known book (*Hunting with the Moon: The Lions of Savuti*) and the National Geographic film *Lions of Darkness*, both by Dereck and Beverly Joubert.

The remarkable behavior of these particular lions includes elephant and hippo kills on a regular basis, as well as unusual behavior among old lions. In Savuti, new prides are always forming and evolving. The most recent changing of the guard came after the reign of the infamous Mandevu (meaning "beard") and the well-documented hyena-killer Ntchwaidumela (pronounced "n-chweye-doo-may-lah," a conglomerate name that means "he who greets with fire"). As the story goes, a coalition of three

Savuti lion, ink and watercolor on rice paper, 2005

THE LIONS OF SAVUTI

In the late 1980s, two lions named Mandevu and Ntchaiwdumela kicked butt, so to speak, in the Savuti area. At that time, hyenas were thriving on the surge of death that came about as a result of the channel drying up. Conflict was everywhere. The lions were fighting to preserve the dried-up territory that was theirs, and Ntchaiwdumela became a well-documented hyena killer, unusual behavior for lions in this region.

Mandevu and Ntchaiwdumela migrated west along the source of the Savuti Channel, ending up at the camp of filmmaker Dereck Joubert. Within days, Joubert says, hunters in the area shot Mandevu. Ntchaiwdumela moped around the Joubert camp for days, looking for his companion, but finally headed back east, never to

be seen again. Joubert suspects that he, too, was shot by hunters.

Two other, shabbier-looking males replaced Mandevu and Ntchaiwdumela in power. Joubert says he and his colleagues watched wave after wave of lions being born and then killed by hunters. The population slowly diminished until mothers mated with their own sons and grandsons, depleting the gene pool and resulting in mangy-looking lions like these two new males. "The degeneration of lion populations in Botswana and the rest of Africa," says Joubert, "has left us with just 25,000 lions in the world and prophecies, like David Quanmann's, that within 150 years there will be no large predators in the world. I think his figures are off by 100 years. I give it 50."

Territorial dispute between two lions, ink and watercolor on rice paper, 2005

A lion on the plain bears a greater likeness to ancient monumental stone lions than to the lion which today you see in a zoo; the sight of him goes straight to the heart.

—ISAK DINESEN, AUTHOR

Lion, oil on copper, 38 x 38 in., 2006

D

Do not try to fight a lion if you are not one yourself.

—AFRICAN PROVERB

Lion, ink and watercolor on rice paper, 2005

male lions (brothers) took control of the Savuti Channel sometime in 1992, forming the Selinda pride consisting of nearly 30 lions, led by three males: Rufus, Blondie, and the dominant TOG (The Other Guy).

It wasn't long before a coalition of five brothers—undoubtedly the offspring of one of these prides, who had been kicked out (as is the custom) and were leading a nomadic life—decided it was time for a new reign. They challenged two of the Selinda males in a violent, three-and-a-half-hour fight, killing one and mortally wounding the other. The newcomers then moved on to TOG, outnumbering the large lion five to one. One member of the coalition was killed, but TOG fell to the attackers, ending a three-year reign.

There were no stable male leaders in the Savuti Channel from 1995 until 2005, when a new coalition moved into the area. Known as "The Four Beers," they are expected to be accepted by the resident pride's females and will continue to control the Savuti Channel.

One afternoon, our guide thought we should take a drive to the edge of the Savuti Channel, where one of the reigning brothers had been spotted earlier in the day. As we traveled we noticed three giraffes off in the distance, all standing absolutely still, gazing in the same direction like soldiers in formation. Our guide slowed the vehicle; the giraffes did not even give us a second look. They had their eye on something far more menacing. One of the four brother lions was lying in the bush, staring off into the sky as if without a care in the world. To the giraffes, however, he was a threat. They were not about to take any chances, but it was doubtful that they would turn and run, for this would expose their delicate hindquarters.

After watching this standoff, we moved on to find another of the coalition brothers and, as dusk settled, we found our quarry. There he sat in all his glory, apparently pondering his evening. From our vantage point 10 to 15 yards away, we watched the sun set on the horizon. The brilliant hues disappeared from the lion's mane as the sun sank behind the edge of the world. Should we go back for dinner? The answer was an emphatic "No." We often skipped meals to enjoy the beauty of these creatures. Darkness settled and our guide pulled out the infrared light to allow us to see the lion without hurting the animal's eyes. After another hour or so the beast stood

and approached us. Our guide quickly instructed us not to stick our arms or legs out, because although the lion is used to our the vehicle, if he sees an unfamiliar outstretched appendage he may go after it, as would any curious cat.

Only five feet from the hood of our Land Rover, the beast stopped. He was a spectacular young male with few scars on his face. He moved closer still, coming alongside the vehicle. I could have reached out and run my hand through his mane, which, although it looked thick, was not as flowing and full as the mane of a Kalahari Desert lion; these Savuti lions run and hunt through the bush, and thorns are constantly tearing at their manes. The regal lion stopped in his tracks, and we were frozen, scarcely daring to breathe. Suddenly he let loose a deafening bellow that lifted me off my seat in fear. This call to his brothers, which could be heard up to five or six miles down the channel, sent a chill up my spine and made my lungs vibrate from the sheer power of the noise. The initial roar was followed by a number of less intense guttural growls and grunts as he continued on through the bush. We followed him for another hour or so until we lost him in the thicker underbrush.

MACHINES IN AN UNTAMED LAND

It is inevitable on any African safari that you will succumb to a flat tire or two. After all, these are not highways; you are driving on rough dirt roads or tracks often strewn with acacia thorns, which have the same effect a nail does on a tire.

Our first flat tire was uneventful; our guide, with jack and spare in hand, fixed it within five minutes and we were on our way again. The second flat started a series of events that I will always remember. The incident occurred many miles from camp, on the same day as the first. The good news was that our guide had replaced the bad tire from the morning flat, so we had a spare. The bad news was that the jack, which had given him a bit of trouble earlier, was frozen in a position roughly eight inches above the bumper. Enter the ingenuity of the human species. We made a half dozen attempts to brace the jack with a dead acacia tree stump behind it, and then point the jack at a 45-degree angle under the jeep bumper while simultaneously propelling the jeep onto the jack so it would eventually stand erect. We then stopped and reevalu-

The endless cycle of life and death is everywhere repeated. There is a sense of times past, of animals existing as they did long before man appeared on the savannas of Africa.

—JONATHAN SCOTT, AUTHOR

Vulture with giraffe carcass, ink and watercolor on rice paper, 2005

ated the rather hopeless situation, suddenly remembering that we had a radio for emergencies. Our guide called in, repeatedly intoning, "Base camp, base camp, this is Thutos, come in please." (I have this memorized because, like a hit song on a radio, you cannot get it out of your mind when it is replayed so many times.) No response from the radio. We went back to the jack and tree stump; almost an hour had gone by. Then it was back to the radio: "Base camp, base camp . . ." Still no response. Okay, now we really had to try the jack-and-stump routine. This time, the jeep rolled up onto the jack. The tire was not far enough off the ground, so we had to dig under the tire to clear enough room to finally change it.

Having had enough of flat tires, the next morning we chose to sit in the hide—an area about ten feet by ten feet, maybe 48 inches high, constructed of large dead trees and set no farther than 15 yards from the camp's water holes. We sat there almost all morning, watching the pecking order of creatures come and go, from early morning with the wart hogs, wildebeest, zebra, and kudu to the midmorning elephants. They all know you are there, but they are comfortable in their natural environment, trusting that you have no intention of interrupting their day. Often an elephant would come over and stare at us, or, similar to what happened to me when we were on the river, would raise its trunk and smell us as we gazed at its gentle eyes and looked at its weathered skin.

Eventually, we decide to leave. As we departed, we had an unbelievable *third* flat tire. Our guide informed us that we had no spare this time—the last flat was being repaired—so it didn't matter that we did not have a good jack. Our position smack in the middle of the channel presented a twofold problem: first, we were in the animals' territory, and second, we would need to walk to camp—not far, but nevertheless a trip through the channel. We needed to time our walk between changes in the pecking order at the water hole, so as not to alarm any of the wildlife coming to drink. We knew to stay in single file, but our guide also reminded us to stay quiet. After several minutes we saw a break in the marching toward the watering hole and proceeded—thankfully, without incident—through the channel to the camp.

THE OKAVANGO

It was our last day at Savuti Camp, and we took stock: we had yet to see two of the Big Five, the cheetah and the rhino. With only four nights of our safari remaining, we hoped this would still be possible.

Our next stop was Vumbura Camp, a remote enclave situated on a private concession of more than 130,000 acres bordering the Moremi Game Reserve, in the extreme north of the Okavango Delta. The world's largest inland delta, Okavango is an enormous oasis in the middle of the great Kalahari Desert. It consists of roughly 6,000 square miles—an area larger than the state of Connecticut—of intricate waterways and reed-lined channels interspersed with game-rich islands, creating a diverse ecosystem that supports the greatest concentration of game in Africa. The plush and beautiful camp, suitable for the pages of *Architectural Digest*, is a favorite of celebrities, and many visit this luxurious oasis.

Our guide here, Cisco, was impressive. He jokingly said he *was* the bush, but this wasn't much of an exaggeration—he was raised in the area and knew it inside and out. Cisco's ties to the area were especially evident when we spotted a lion with a huge red mane and he told us his name was "Big Red"—an old, dominant male of two rival prides here. Big Red ruled over the Kuvu (meaning "hippo") pride; the other is called the Kwidi ("moon") pride. This provided another interesting illustration of unusual lion behavior. Apparently, Big Red had kicked two of his male offspring out of his pride when they were about three years old. The two sons maintained a nomadic lifestyle for two years, at which time they decided to come back and challenge their old man. But instead of killing their father, which is usually what happens, they did the old lion a favor and decided to let him live out the rest of his life here, as long as he didn't breed and recognized his sons as the dominant males.

Vumbura was another terrific spot for sighting leopards, which we found. However, although we chased some wild dogs and tried to track a cheetah, luck wasn't with us. There was one more camp to go, but our time was running out.

Guide tracking, charcoal on cold press paper, 2005

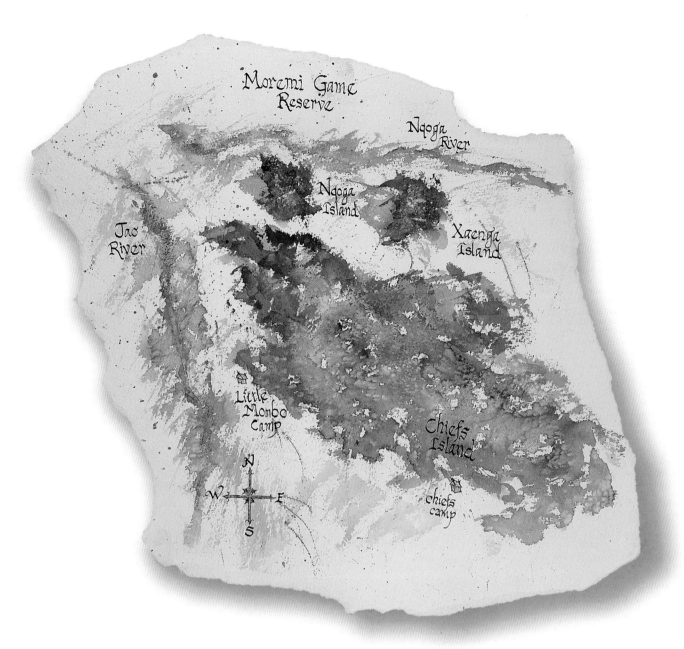

TRACKING AT LITTLE MOMBO

We flew by light charter aircraft into our next camp, Little Mombo, which is located on Mombo Island, adjoining the northern tip of Chief's Island, also within the Moremi Game Reserve in the Okavango. If we were to spot cheetahs and rhinos anywhere, this had to be the place; the area was known for its abundant big game, arguably the best in Botswana. The camp was excellent, nestled into a large shady grove of trees overlooking a vast flood plain teeming with animals. There were three "luxury" tents, connected to the living areas by walkways raised about six feet off the ground, allowing game to wander freely through the camp. The dining room, bar, living area, and plunge pool were also raised on stilts, affording glorious views over the open plain in front of the camp.

Map of the Moremi Game Reserve, ink and watercolor on cold press paper, 2005

Thompson, our guide here, knew he had his work cut out for him the minute he met us at the airstrip. He asked us what we'd like to see, and we answered with the two hardest-to-find animals in southern Africa. But we focused our efforts and spent the next two days tracking rhinos and cheetahs.

The first day wasn't rewarding in that regard, but we were lucky enough to see a leopard in a tree with its kill. A common practice with leopards is to keep their meal away from scavengers like hyenas and jackals. We were only a short distance from it—and it was a spectacular thing to witness. The leopard hissed at us; you could see its sharp teeth and its piercing green eyes. It didn't want us to come too close to the impala it had chased, killed, and painstakingly dragged up into that tree.

We also spotted a dominant male lion that Thompson called Bob Marley, explaining that although the guides normally don't like to name lions or any animal after people, this particular lion had a unique Rastafarian-type curl underneath his chin, so Bob Marley he was. His pride—maybe 17 lions, lionesses, and cubs—was naturally called "The Wailers." Thompson explained that a group of lions known as the Wheatfield pride originally held the territory here for about seven years, but when Bob Marley moved in, he evicted the young. The old males of the Wheatfield pride, in an unusual move, allowed those evicted young to join in with them, thus keeping Bob Marley and his new pride from controlling the whole territory.

Bob Marley and a Wailer, charcoal on cold press paper, 2005

WATER IN THE DESERT

The Okavango River, known as "the river that never reaches the sea," flows south from its birth in Angola, forming part of the Angola-Namibia border before it winds into northwestern Botswana and disappears. Well, technically it doesn't "disappear," but it is a river no more, instead transforming into the Okavango Delta (or Okavango Swamp) in Botswana, the world's largest inland delta. Each year more than 4,000 square miles of water reach the delta, flooding the area on a seasonal basis, beginning about midsummer in the north and six months later in the south. High temperatures cause 90 percent of the water in the delta to evaporate relatively quickly, so the water levels rise and fall, sometimes caus-

ing islands to disappear completely during the peak flood season, only to reappear later as the waters recede.

The Okavango Delta was once part of Lake Makgadikgadi, an ancient inland sea that dried up some 10,000 years ago. But the present-day swamp, filled with water that is unusually pure thanks to the lack of industrialization along the Okavango River, has proved to be wonderfully beneficial to the flora and fauna of the area, as well as to the people who inhabit these lands. The region is particularly known for its large numbers of elephants, which migrate to the delta for its consistent source of water and food amid an otherwise barren landscape. It is not only elephants that favor this habitat; more

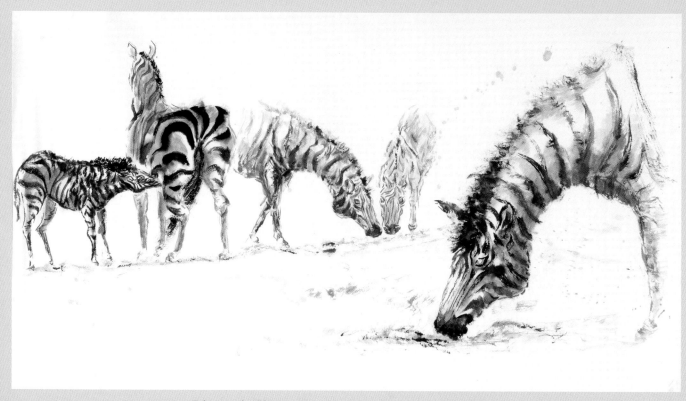

Zebras on the Okavango Delta, ink and watercolor on rice paper, 2006

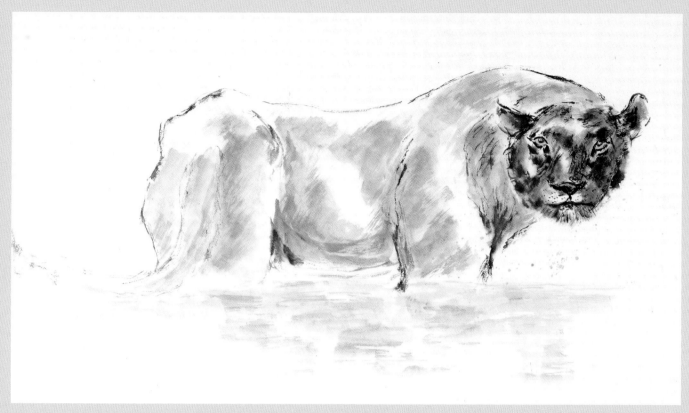

Lion on the Okavango Delta, ink and watercolor on rice paper, 2006

than 160 species of mammals, 500 different birds, 18 amphibians, 157 reptiles, and 89 fish call the Okavango their home.

The delta also provides sustenance for the five ethnic groups that reside here, each having its own cultural identity and language. They are engaged in mixed economies of millet and sorghum agriculture, fishing, hunting, the collection of wild plant foods, and raising livestock.

One of the most noticeable things about the Okavango Delta is the complete absence of rocks. The landscape is as flat as a lake, leading to the formation of the delta, because the water entering it has no clear course to follow. This has created an oasis in the desert, where channels and lagoons, riverine forest, flood plains and seasonal grasslands, woodland, aca-

cia scrub, and palm savanna all coexist to form distinctive habitats for the many species that reside here.

Because of the ever-changing water levels, you never know what you might find here. You may wake up one morning to find yesterday's quiet plain teeming with hundreds of animals and water birds flocking to the marshes. The sparkling, shimmering fingers of the delta stretch out into the desert, transforming an otherwise foreboding landscape into a miraculously lush haven for all.

Cheetah track, ink wash
on rice paper, 2005

We got back from our afternoon outing and were relaxing in our tent when some Cape buffalo came up right outside the door. They approached to within about three feet, and then they refused to move. Needless to say, we weren't going anywhere until they decided to clear off; this was not an animal we wanted to challenge.

The next morning we found a leopard named Legodima, which means "thunder," under our tent. We hoped it was a good omen for the day of tracking ahead.

We were elated to actually find some rhino tracks. The tracking was extremely interesting in itself. To me, the ground looked hard and as clean as a slate, yet when Thompson looked at the same spots, he said, "The rhino came through here." He noticed every clue, perhaps a broken limb or a spot where the rhino had recently urinated. However, this was not enough. We looked all day for that elusive rhino—and still no luck.

The last day was upon us, and we were still determined. We again found some tracks that led into an area outside the perimeter of the camp. Thompson was adamant that we were going to find that rhino. "He was headed this way," he said. "You don't realize how far these guys can travel. If a rhino wants to go somewhere, or a cheetah wants to go somewhere, they're moving. You're not going to find them easily."

Thompson found some cheetah tracks, but no cheetah was anywhere within sight. He remembered that another guide had spotted rhino tracks somewhere else, so he turned our vehicle sharply to head off in another direction. Then he suddenly said, "There it is!" We only laughed, because, by this time, even a bush looked like a cheetah. But Thompson insisted, "No—there it is!" and in his excitement he nearly drove our vehicle right into a big termite mound, on top of which stood our elusive cheetah.

THE CHEETAH

The world's fastest animal, the cheetah (*Acinonyx jubatus*) has semi-retractable claws that act like cleats and enable it to take strides approaching 25 feet. This remarkable animal has exceptionally large lungs, nostrils, and heart, which allow it to take in plenty of oxygen for its bursts of acceleration: its chase rarely lasts longer than 20 seconds. The cheetah hunts in open grasslands and woodlands, where it can use its

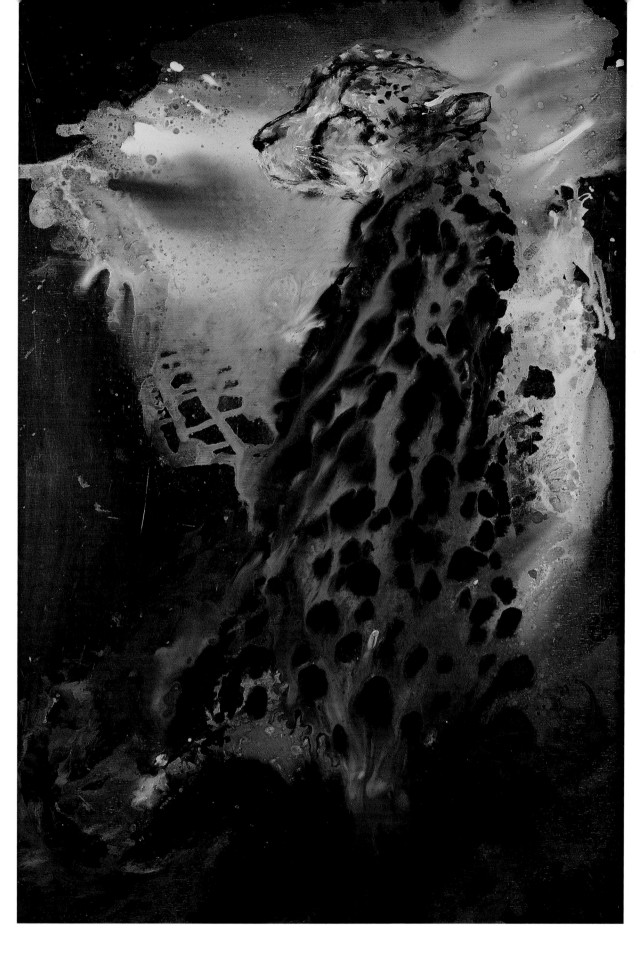

Cheetah, oil on copper, 26 x 38 in., 2005

Exalted and denigrated, admired and despised, no animals have so aroused the emotions of man as have the large predators. . . . Yet at the same time these predators have been and still are persecuted to such an extent that they have vanished from much of their former range.

—GEORGE SCHALLER, AUTHOR

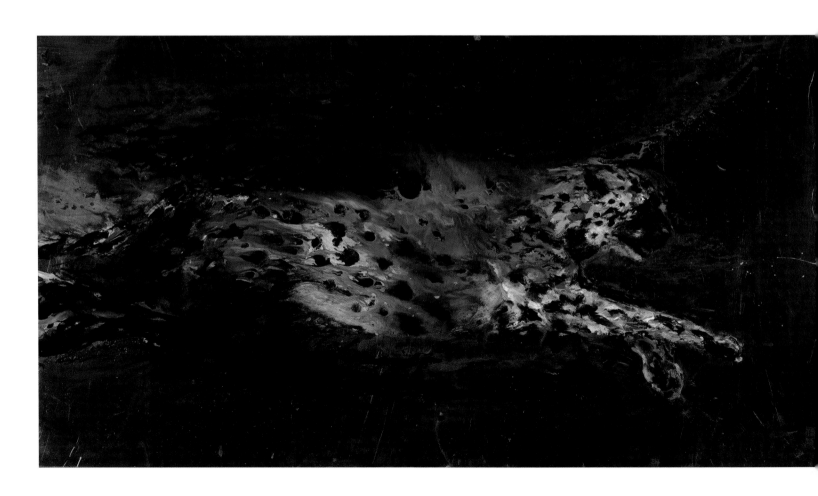

Cheetah, oil on copper, 48 x 26 in., 2005

CHEETAH (*Acinonyx jubatus*)

MARKINGS: Tan or buff-colored fur with black spots; distinctive black tear lines on the sides of the muzzle, which keep the sun out of its eyes and aid in hunting and long-distance vision. The tail has spots that merge into three or four dark rings at the end.

SIZE: Adult animals can weigh from 90 to 140 pounds, and its total length, including tail, is just over seven feet.

BEHAVIOR: Cheetahs are very solitary animals, with males living alone or in coalitions of brothers, and females raising the young completely on their own. Although chiefly nocturnal, cheetahs do move about by day, patrolling widely for prey. Surprisingly, cheetahs are fairly nonvocal, only uttering a bark when calling a partner. It is the only member of the cat family that hunts by speed rather than by stealth or pack tactics. It is the fastest land animal on earth, reaching speeds of up to 70 mph for short bursts of 500 yards or so and strides up to 23 feet. Unique among cat species, the cheetah has semi-retractable claws, offering the cat extra grip in its high-speed pursuits.

GESTATION: About three months, with litters usually consisting of two to four cubs, sometimes as many as six. Kittens have their characteristic black spots from birth. The first 18 months of a cub's life is very important; this is when it learns how to hunt and how to avoid other prey species. Death rate is very high in the first few weeks of life; up to 90 percent are killed by predators during this time.

LIFE SPAN: Up to 17 years recorded.

PREDATORS AND PREY: Cubs are vulnerable to lions, leopards, hyenas, baboons, and eagles. Almost any mammal up to 90 pounds is prey to cheetahs, as well as birds up to bustard size (which at times are caught on the wing with a high jump) and reptiles, including poisonous snakes. Cheetahs may also attack smaller domestic livestock. They sight their prey from a termite hill or the branches of a low tree, stalk to within 100 yards, then attack at a gallop and pursue for up to 500 yards at high speed. They tackle the prey, then hold with a throat grip for five to 10 minutes. Often drag the prey to cover and eat it on the spot.

DEFENSE: The cheetah is a vulnerable species, but defenses include speed as well as sharp teeth and claws.

CONSERVATION: Cheetahs are considered a threatened species by the Convention on International Trade in Endangered Species (CITES). Approximately 12,400 cheetahs remain in the wild, in 25 African countries. Once widely shot for its fur, the cheetah now suffers more from loss of both habitat and prey; its numbers have also dwindled due to high cub mortality. Some biologists believe the cheetah is now too inbred to flourish as a species.

speed—upwards of 70 miles per hour—to its advantage. The cheetah has a flexible spine and, when running at full tilt, all four feet are off the ground in both the flexed phase and extension phase of its movement. It takes three strides every second. Females are solitary unless they have cubs, which are born without teeth and are unable to see or walk for about a week. When the cubs are older, cheetah mothers often injure their prey and then release it, allowing their cubs to practice and improve their hunting skills.

This cheetah was a large male; the guide called him "the loner." He looked over his shoulder at us and then took off. We tracked him; he ran to get some water at a nearby water hole, then stopped and caught the whiff of some impalas that had just crossed his path. He made a short burst, a sprint the likes of which I had never seen before. It looked to us like he was going for a kill, but Thompson said no, he was just playing with the impalas. We followed the cheetah for about an hour and a half; he moved on to sit on another mound and then went into some very thick underbrush, where we lost him.

Satisfied by our adventure with the cheetah, it was time to turn our attention back to the rhino. Another guide radioed and alerted Thompson to some tracks he had seen earlier. Thompson went to the spot and got out of the vehicle, but forbade us to leave it. He showed us a couple of tracks; he had seen fresh urine markings, from within the last 15 minutes. He went off to see what else he could find.

The next few minutes provided one of the most unusual feelings I've ever experienced. There we were, sitting in a vehicle in the middle of Africa, in the middle of God's great planet, with nothing around but trees and barren desert. There were no other cars, no airplanes, no other people. There were no buildings as far as you could see. Our guide had disappeared into the bush, as far as we knew, never to return. We sat in that open vehicle with nothing with which to defend ourselves against one of the chance encounters we had enjoyed so many times during this adventure. We understood that we were completely vulnerable to the ways of nature, and no more significant to the circle of life than the termites teeming in the nearby mound.

Five minutes went by. Ten. Fifteen. Should we look for him? No, he'd said to wait. Twenty minutes, maybe more, went by. I'm happy to say that finally Thompson came back, and with a huge smile on his face. "I got him!" He climbed in and we drove through the bush, and there it was: a mother with a baby.

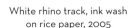

White rhino track, ink wash
on rice paper, 2005

White rhino, ink and watercolor on rice paper, 2005

THE WHITE RHINO

Thompson said the baby was probably the one they had heard was born on Valentine's Day and was named Valentine; it was seven months old. We were overwhelmed. The white rhino is the largest land animal after the elephant, with a large body and short stumpy legs. Males can weigh up to 7,700 pounds; they can reach a shoulder height of six feet, and a length of 15 feet.

The white rhino has two horns, with the larger front horn growing up to three and a half feet long. It has very little hair—just the odd tuft on its tail and ears. With a muzzle shaped perfectly for chomping grass on the flat grasslands of Africa, it will happily munch by day or night. Although rhinos look prehistoric and tremendously fierce, they are actually quite gentle. Fully grown males are territorial and will mark their patch by spraying urine, spreading dung, and scuffing plants. They will confront challenges from other bull rhinos with an impressive display of horn butting and false charges, but white rhinos will very rarely fight.

Not surprisingly, the biggest challenge to the white rhino's continued existence is human activity. Although many efforts have been made to establish conservation initiatives in the white rhino's natural habitats, economic hardship and civil disturbance have led to encroachment on protected areas and an unwelcome rise in the number of poaching incidents. The long-term effects do not bode well for animal or human. While safer than some species, the white rhino remains on the brink of extinction.

The mother was very protective of her baby; she noticed we were there, so we could only get within 30 yards or so. However, it was close enough for me to use my camera's zoom and get some good pictures. We watched the two for a while—until we realized we only had five minutes to catch the first plane in our journey back to the United States. We hurried to the airstrip, scarcely leaving time for good-byes. It wasn't until later that we realized we had just completed a journey of a lifetime, one that had changed each one of us in his or her own way. My concern now was how to capture all this magic and wonder in my paintings. I didn't want to forget one moment; Africa had left a mark on me that will endure forever.

White rhino (detail), oil on copper, 30 x 38 in., 2005

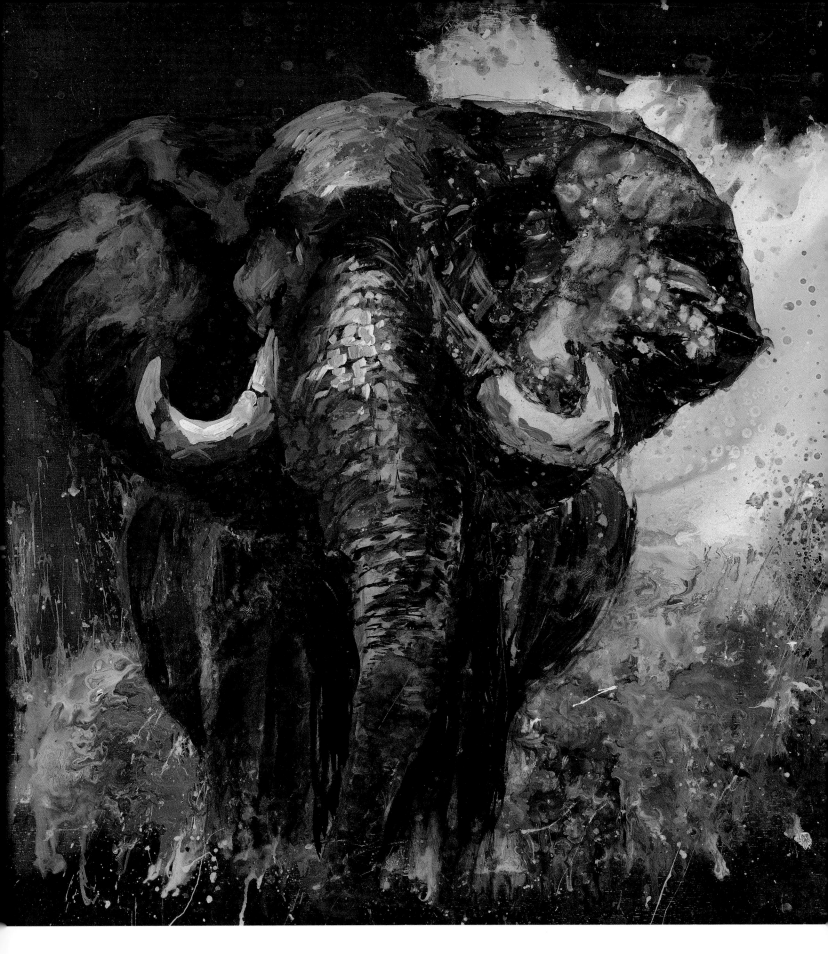

Elephant, oil on copper, 30 x 32 in., 2005

An Artist's Safari

AFRICA IS A SPECIAL PLACE for artists. Maybe it is because the air is clearer here; there are no billboards to interrupt one's gaze, no honking horns. The only noises you hear at night are the hippos snorting in the river outside your tent, the hyenas giggling madly at the sight of a new kill, the lion's halting roar as it announces its domination. It's Africa, raw and simple.

Artists, perhaps like photographers, are given the gift of detail. We see every light, every shadow, every color, every expression. But while a photographer can only capture the moment, I feel as an artist I can contribute even more to the image of what I saw by adding perhaps that extra brush stroke or that extra splash of color where you least expect it. An artist can combine his feelings and his passion with what he saw and come up with something unlike any photograph ever taken.

There are some artists, of course, who paint quite photographically, and that is admirable in itself. Of course I refer to my photographs quite a bit while I'm painting, but my style is not a photographic one. My personal feeling is: if you want a picture, take a picture. Not that I have anything against artists who do have that style, but to me it has no motion, no movement, no action. I never saw an elephant or Cape buffalo or *any* animal in Africa that was standing still, as if to say "Hey, paint my picture, I'm smiling!" To me, the only way to get a good piece of art is to capture the motion of the subject. There's always something happening. It may be a twinkle in the eye, it may be a smirk, it may be a mere wrinkle, but there has to be some movement; there's always motion, period. That is the Africa that my artist's eye saw.

Sketching at camp along the Zambezi River

CHOOSING YOUR FOCUS

As an artist, you've got to be very careful about how you go on safari. You are going to want to come home and capture it on canvas, or on copper, or whatever your chosen medium is, but you need to decide on your focus before you go. Is it the fascinating and unpredictable wildlife? The vistas and the unique and ever-changing scenery? This is just the beginning for the artist. What about the way the light plays upon land and changes it throughout the day, and from day to day? What about the finely tuned bodies of the animals, which are structured to allow them to survive in this unique environment? Africa has astounding beauty in all its aspects, and it can easily overwhelm. Instead, I suggest you choose your focus before you go, determine the thing you will look for first. However, you will want to be open to changing that focus once you are there, for you never know what will strike you in this land, on this particular visit.

Once you decide on your focus, choose a safari outfitter who can cater to your special needs and get you to where you should go. Use the Internet as a resource to find specific outfitters who specialize in your interests. Take my word for it, you're going to want to sketch and have ample freedom to control your schedule. Make sure you keep this in mind as you investigate outfitters.

ARTIST'S SUPPLIES

What do you bring? You'll find your luggage weight very limited. Bring the essentials as far as clothing is concerned (knowing that there will be laundry service along the way), and focus instead on the tools of your trade.

I had a specially designed case made for me to take on safari. It held my brushes, charcoal (willow charcoal sticks of varying thicknesses), a variety of pencils, sumi paper, a 9x12 spiral-bound sketchbook, a small can of fixative to protect my sketches, kneaded erasers, a pencil sharpener, and graphite. I sketched primarily with charcoal and pencil but also used colored pencils. I brought some watercolor pencils, too; but they didn't work as well as I thought they would.

There are a few items on any list that you won't want to do without. First and foremost is a pair of *excellent* binoculars. I got the same kind of binoculars hunters use, and that meant I couldn't go cheap, but it's an investment I didn't regret. Although you often get close to the game, you'll want to absorb every detail, every expression, in order to imprint it in your memory to recapture it on canvas later.

I also got a binocular strap. It's a shoulder harness of sorts that keeps the binoculars tight against your chest, so that when you're running (and if you're on a foot safari, you may well be doing just that), your binoculars won't bounce around. When you stop, you can pull the binoculars right up, because they're on a little swivel release.

Of course, you'll want just the right camera. It took me about a month to find the one I wanted. I ended up purchasing a digital that had a little 10 X zoom on it, and that worked very well. You *do* need a zoom. Make it your priority to learn how to use the camera before you go. You don't want to be messing around with exposure and light meters and so forth. You need something that's going to take the photo quickly when you want it, and then free you up to take in what you're expe-

With camera in Okavango Delta

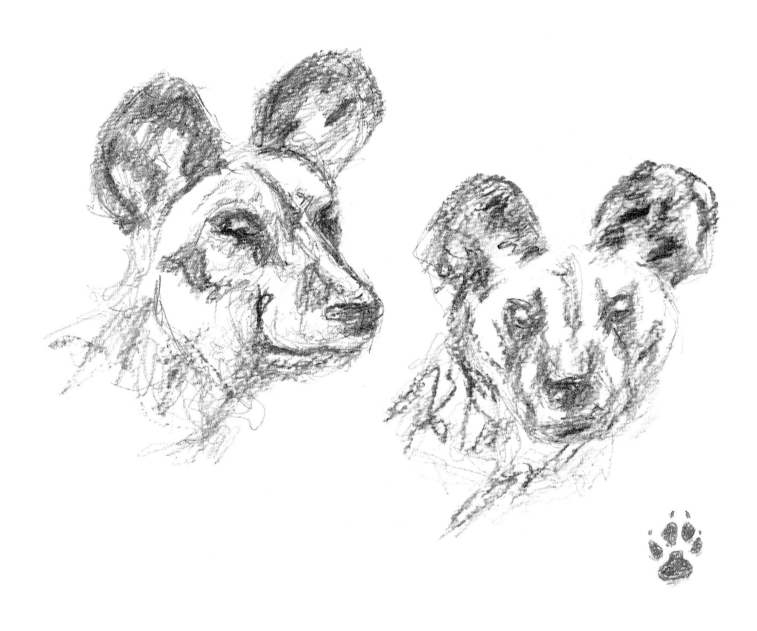

Pair of wild dogs, charcoal on cold press paper, 2005

riencing. You don't want to be glued to a viewfinder. My camera had digital video on it, too, though I didn't choose to use it.

A photographer's vest, with many pockets, is also very useful, because there are many things you'll want to have along with you. No matter where I was going—with the possible exception of the shower—I always had pen and paper, a tape recorder (a little digital one about as big as my finger), binoculars, and a camera. I kept it all close by in my vest.

PHOTOGRAPHY FROM AN ARTIST'S PERSPECTIVE

Whether I was running after wild dogs or even sitting and observing the elephants, I didn't sketch in the field. Instead, I took photos of things I knew I would sketch later. I would take in the scene in front of me and picture my canvas in my head. Then I would snap the pictures I needed to help me remember the angle of the animal's head, the colors of its mane, the relationship between the spread of its ears and the splay of its feet.

What are you looking to photograph? Personally, I'm looking for action. I want to get the animal moving; I want to capture an expression. When the elephant's charging and I'm in the right spot, I want to make sure I've got it coming right at me—boom—and I've got the picture. I've got my finger ready to make sure that as it's coming at me, I'm taking another picture and another.

My work is all about spontaneity. That's what I love about animals, whether horses or leopards or lions. There's always action; they're always doing something. Animals are alive—they're *totally* full of life. Trees, mountains—you can make them come alive, but you can't make them move, the way you can leopards and lions. People think of artists going on safari and setting up their stool and easel, but it wasn't that way for me. You're moving so far; things are going so fast. Landscape painters might be able to use an easel, but not wildlife painters.

However, you have to have one focus. Whether it's an animal's face, or eyes, or mouth, your subject will have a distinctive focus. When I'm taking my photograph, I'm focusing on what I want out of it. Do I want to capture the elephant coming

Honey badger, charcoal on
cold press paper, 2005

at me? Do I want its ears as they're fanning out, or its trunk as it's thrashing through the bush? The odd thing, as you notice from a lot of my elephant art, is that you don't see the elephant's eyes. They're there, but you don't see them. Whereas when you look at one of my lions, its eyes are popping out at you, because that's a more distinctive characteristic of a lion. With the elephant, it's more the ears and the trunk. With a rhino, it's the horn. So I'm not as concerned, when I'm getting a photograph, that I get that paw just right; I'm using my photos only as reference.

To me, the priority is always the experience. What's going on here? How am I reacting to it? Grab the sensation, and recreate that feeling for the viewer in your painting. Capture it with the motion, because there's always motion with animals. Even when the animal is still, there's motion—a flick of the ear that is listening for every sound, a tip of the nose that's catching a mysterious scent, the shuffle of a foot ready to spring at the least provocation. You must grab all this in a split second; you have no time to analyze that its eyes are like this and its mouth is like that. You've got only a second to sketch two or three lines in your mind. After you burn the image into your mind, put it on paper so back home you can transform it—to copper, or canvas, or whatever.

The downside of being an artist with a camera is that, because you want to engage in the experience, you may miss the first shot. That is exactly what happened when I saw the leopard screaming. I was so captivated by the experience that when her baby suddenly came running out, I *totally* forgot about the camera. As an artist, you sometimes miss photographic opportunities because you're taking in the full impression of what's going on. But it's there, in your mind. I could recapture that moment with the leopard in a minute and draw it in no time at all.

KEEPING AN ARTIST'S JOURNAL

I don't know what I would have done without my artist's journal. I wrote in it every day. It is where I worked through my priorities, determined my focus, and jotted down my impressions. I got up at five o'clock every morning and noted the things I was going to look for that day. I tried to organize myself. But the problem is, you never know what's going to happen! While the day is going on, you're taking pictures, or you're making quick, little notes. These became valuable, because when you're in a canoe and a hippo is charging you from the right-hand side, and you've got a guide saying, "Back paddle, back paddle!" you don't have time to think of anything specific in all that excitement!

On the canoe trip, we usually stopped four times a day: midmorning, then for lunch, then midafternoon, and again in the evening. During those stops, I would jot down notes on what I had just seen. I may have written six or seven lines, just to remind myself how the hippo came at us, and from what angle he approached. I used those notes a lot when I got back home and started painting; I keep them right next to me. It's enough to bring the experience back, as if it had happened only yesterday. I get excited all over again. You don't forget those incidents.

In addition to my journal, I had a little digital recorder with me wherever I went. I would record only about three hours a day, but that was enough. Every night at camp, after dinner, I would transcribe the verbal notes I had made, and then erase the recording to be ready for the next day. That hour at the end of the day was important to me; I'd either fill in my sketches or transcribe my recordings, or both. Those sketches and my journal provide me with even better memories than my photographs.

When I returned to America and the comforts of home, it was my vivid memories, my notes, my sketches, and my photos that were my lifeline to the marvelous and mysterious world I had left behind. The daunting task that lay ahead of me was capturing it all through my art.

Porcupine, charcoal on cold press paper, 2005

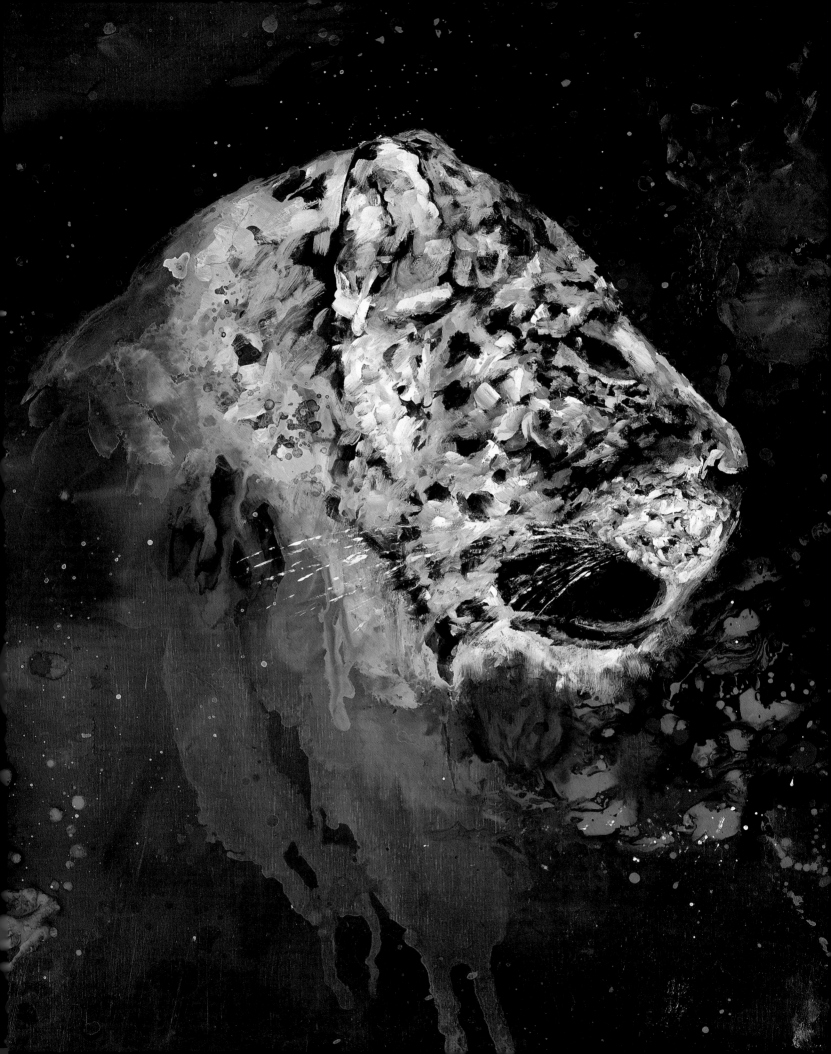

An Unlikely Artist

OU PROBABLY WOULDN'T THINK
I was an artist if you were to meet me. In fact, I feel like I've got somewhat of a split
personality, since my business for many years has been dealing with numbers; stocks,
in particular. That part of me couldn't be farther from the art world. But I can't
remember a time I wasn't interested in drawing, or animals for that matter. This may
seem surprising, given that I grew up in the small town of Lima, Ohio, which isn't
exactly a haven for wildlife. My parents used to take me to the zoo a lot. The Colum-
bus Zoo. The Cincinnati Zoo. They *loved* the zoo. In fact, every time we went on
vacation, we found a zoo. Even to this day, if I go on vacation, I find the zoo in what-
ever country I happen to be visiting.

I'd come back home from those zoo trips I took as a boy and draw what I had
seen. It was a way to tie together those two early passions of mine: wildlife and draw-
ing. I had no idea how much I drew as a child until my mother (who never throws
anything away) one day presented me with literally volumes of drawings I had done
—and they were pretty much all drawings of animals. Lions, tigers, leopards, griz-
zly bears. Generally speaking, I've always liked animals more than people. I don't like
doing portraits. You want a painting of a Dahl sheep? I'm your man. You want a pic-
ture of your mother? I'm not that guy.

Mixed in with my interest in animals and art was an innate sense of adventure
that first came to light in a big way when I was about 20 years old and had won $500

Leopard (detail), oil on copper, 38 x 26 in., 2005

Reading with my grandfather, age five

at a poker game. Feeling rich and ready to face the world, I hitchhiked from Lima, Ohio, down to Dayton, went to the airport and asked for a ticket to someplace warm. That place turned out to be Arizona. I never turned back.

It wasn't until I was attending Arizona State University that I more formally rekindled my early interest in drawing by taking some art classes while working on my business degree. I was *always* drawing. But the sensible side of me said I had to get a "real" job, and it was business that I initially pursued, first turning to the field of banking. Later, in 1986, I became a financial adviser, and a successful one at that: my business continues to thrive to this day. But something was missing.

TALES OF AFRICA

About the same time I went into the world of finance, I was at lunch with a friend who introduced me to Jeff, who traveled often to Africa since he worked in Tanzania. We became fast friends. Although I've never hunted or even held a gun, Jeff convinced me to accompany him to Safari Club International's annual convention—held at that time in Las Vegas, Nevada, and now held in Reno—to meet some of the

world-renowned artists who exhibit there. This large show brings more than 20,000 buyers and exhibitors together, with attendees spending millions of dollars on dream safaris, wildlife art, jewelry, and more.

At these conventions I became fascinated with the stories the safari guides told around the bar in the evening of their adventures in the bush. For ten years, I listened to those stories. I kept thinking, "One day I'm going to paint this, I'm going to paint that..."

THE ART OF SUMI

In the late 1990s, when I was continuing to pursue my love of drawing and painting, taking classes here and there, Margaret, a watercolor artist and instructor, suggested I expand my media and art techniques from just watercolor and pencil sketches. She introduced me to Wei Tai, who was trained by the Oriental master Zhu Qi Zhan at the Shanghai Art Institute. Initially our cultural differences were achingly apparent: as an American, I wanted to learn everything *now*, but Wei Tai was determined to introduce me to *his* world of art by first building a foundation upon which I could become an accomplished artist.

It was like *The Karate Kid* all over again! I had to forget everything I had learned in the past about shortcuts to a finished painting. There were no shortcuts here. There were no watercolors, no paintings of animal composition, no use of *any* Western medium at all for nearly six months. Wei Tai introduced me to sumi, which is an ancient Far Eastern method of painting on highly absorbent rice paper with ink, using a bamboo brush. Initially he shared an old brush with me. The brushes we use are made of weasel hair, which has more spring or life to it than other types of sumi brushes. They're very difficult to find in the United States.

For four months I painted nothing but bamboo and bamboo leaves, using composition and shadow. Occasionally

Sumi ink brush

Wei Tai would let me add a small bird, just to keep my interest. He would harp on me about not doing enough practice or homework, relating how he, as a child, would paint 100 sheets a week. I was doing maybe five.

Just when I had my fill of painting bamboo and was considering throwing in the towel, Wei Tai reviewed my progress. He made me see how I could now control the water and ink in the brush together, making shades of ink from black to nearly clear. This was a huge step forward in my art. We moved on to painting animals—one at a time, slowly, until I had mastered each technique. We then moved on to other media and different styles, enabling me to find my own unique "loose" style of painting, which allows me to capture the motion in my subjects. Even today, when warming up my brush, I often start with—you guessed it—bamboo.

In addition to doing sumi paintings, I like to paint on silk and copper. Both are ancient methods, but they produce very different results. In the early 16th century, a small number of Italian artists who were experimenting with various smooth surfaces, such as slate and marble, found thin sheets of copper to be the ideal surface, and the practice spread throughout Europe and the New World. Not much preparation of the surface is required, and there is no absorption of paint as there is with canvas or wood. I also feel the copper tone gives further dimension and life to my work; I often purposely let bits of copper show through my brush strokes.

The nice thing about my loose style of painting is that there may be lines outside the actual image, the result of trial and error—but they're actually essential. With wildlife in particular, I want to do my sketching just to, say, get the shoulder higher. If I have a line that's not right, and I have to go over that line, I may or may not erase it. By not erasing it, it's sometimes more energetic, more alive, like the animal.

As I look at the sketches I did on safari and my photographs, I'm remembering how that lion held its head. I'm remembering his muzzle, his facial expression, the character of his cheekbones. Now *that* is a majestic animal! If you look at a lion close enough—and we were fortunate to get within eight to ten feet at times—and you see the color of its eyes and the detail of its pupils, you feel the power of this wonderful creature. This is what I try to capture when I put my brush to copper or silk or paper.

MY SIGNATURE

Many people notice the red seal on my sumi and copper paintings. This is a Chinese tradition that dates back many centuries. It is common in most cultures to see artists sign their work, but in the Chinese culture, artists (including poets, painters, and even calligraphers) use a special carved seal to mark their art. Each one is unique; every time an artist stamps his or her work with the seal, that artist is signing the work. There is a great deal of pride in finding a seal that is a unique and artistic expression of one's work. My master, Wei Tai, told me that generally the family patriarch would help a family member who was an artist design his seal. Wei Tai's grandfather designed his father's seal, and Wei Tai's father designed his. I am proud to say that Wei Tai designed my seal for me a couple of years ago, after he felt I deserved one. My seal is of very high quality and is made of stone, with my Chinese birth sign—a dragon—hand-carved on top of it. It is priceless.

My passion to paint creates an emotion to convey, on canvas, rice paper, silk, or copper, what I feel. As an artist I have the ability, with the stroke of a brush, to transform an ordinary expression into a dramatic one. My happy mistakes are part of being an artist. Each piece of art I create is a journey of its own. For example, while I was working on the bronze elephant relief (see page 34), I was never sure how it would turn out, but regardless I enjoyed molding the trunk and remembering how the elephant charged me; I remembered looking at his weathered skin, and smelling the musk in the air. The artist holds the image in his eye.

No picture of art is perfect to the beholder. Artists are always trying to improve, to be the best they can with the ability given them, knowing there are mistakes in their work just as there are mistakes in life. Sumi painting on rice paper and silk has taught me that accidents happen and reminds me to always look for ways to make them work. Above all, my journey as an artist has taught me that success is truly rewarding only when shared with others.

Chop and seal designed by Wei Tai

Acknowledgments

I would like to thank the following people for their involvement in this project:

Pierre and Margaret Faber of Classic Africa. Without their contacts this book would not be as complete.

The guides, who shared their immense knowledge of their countries and the talents of their trade.

The gracious people of Africa, for sharing their country.

Karla Olson and Pam Swartz of BookStudio, for guidance and direction. It has been one helluva journey and a learning experience.

Barbara Balletto and Sandy Bell, for the terrific manuscript and the wonderful design and layout of this book.

Family and friends, for all their support of my artwork and my book.

Bibliography

Coppard, Kit. *Africa's Animal Kingdom: A Visual Celebration*. New York: PRC
Publishing, 2001.

_____. *Big Cats*. Edison, N.J.: Chartwell Books, 1998.

Donaldson, Kim. *Africa: An Artist's Journal*. New York: Watson-Guptill, 2002.

Haas, Bobby. *Through the Eyes of the Gods : An Aerial Vision of Africa*. Washington, D.C.:
National Geographic, 2005.

Joubert, Dereck, and Beverly Joubert. *The Africa Diaries: An Illustrated Memoir of Life in
the Bush*. Washington, D. C.: National Geographic, 2000.

_____. *Hunting with the Moon: The Lions of Savuti*. Washington, D.C.: National
Geographic, 1997.

Zeisler, Gunter, and Angelika Hofer. *Safari: The East African Diaries of a Wildlife
Photographer*. London: Eddison Sadd, 1987.

Index

Figures in italics refer to illustrations.

Africa: An Artist's Studio

was printed by Golden Cup Printing, Ltd., in China.

The text typeface is Adobe Jenson designed by
Robert Slimbach in 1996 based on the Venetian Oldstyle
originally designed by Nicolas Jenson.
The display typeface is Juanita ITC and Juanita Xilo ITC
designed by Luis Siquot in 1996.

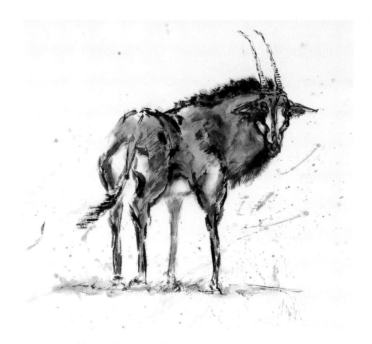

Sable antelope, ink and watercolor on rice paper, 2006

INFORMATION AND ORDER PLACEMENT

For additional copies of *Africa: An Artist's Safari*,
please visit your favorite bookstore
or contact us at:

Maverick Brush Strokes
11914 East La Posada Circle
Scottsdale, Arizona 85255
www.maverickbrushstrokes.com

For more information about the paintings
in this book, please go to:

www.maverickbrushstrokes.com